POSTCARD HISTORY SERIES

Skaneateles Lake

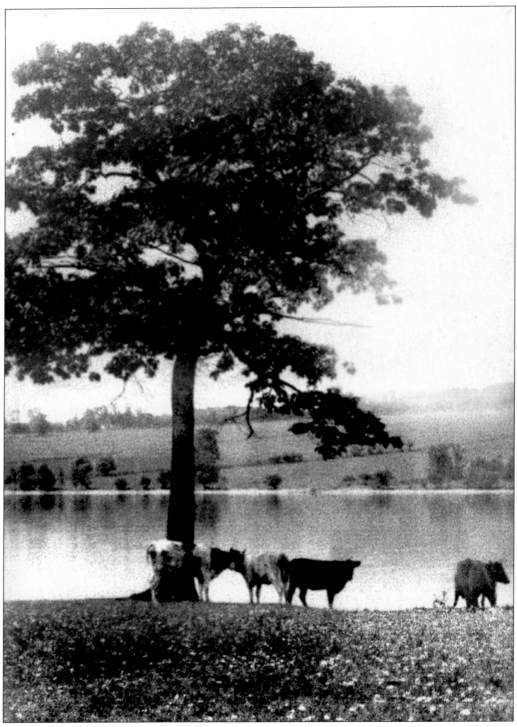

The photograph for this postcard was taken at a time when cows and farm fields quite literally ran from the roads above to the lakeshore itself—sadly, a pastoral era now long gone.

POSTCARD HISTORY SERIES

Skaneateles Lake

Paul K. Williams and Charles N. Williams

ARCADIA
PUBLISHING

Published by Arcadia Publishing
Charleston SC, Chicago IL, Portsmouth NH, San Francisco CA

Printed in the United States of America

Library of Congress Catalog Card Number: 2002110469

For all general information contact Arcadia Publishing at:
Telephone 843-853-2070
Fax 843-853-0044
E-mail sales@arcadiapublishing.com
For customer service and orders:
Toll-Free 1-888-313-2665

Visit us on the Internet at www.arcadiapublishing.com

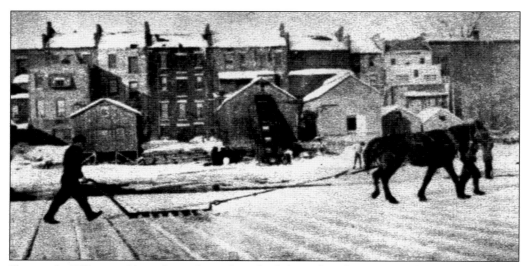

Skaneateles Village residents have always benefited from their location on the beautiful Finger
Lake, from the time that it provided blocks of ice, seen here in the 1880s, to the present-day use
of the lake for recreation, fishing, and summer strolls in the parks.

CONTENTS

ACKNOWLEDGMENTS

The authors dedicate the work herein to the many present, past, amateur, and professional historians who throughout the years have brought light to the history of Skaneateles and the lake. The book is dedicated to the memory of four late individuals who always made sure that local history was on the agenda and were not afraid to speak their minds and correct many of the stories, publications, and histories written to date—a truly never-ending mission. They are Catherine Barnes, Donald Stinson, Helen Ionta, and Ruthann Carr.

The authors would like to thank all the friends and family members who helped make this book possible, including Arcadia editor Pam O'Neil, who sent and received many a package to and from Skaneateles, Owasco, Washington, D.C., Los Angeles, and even Hawaii during the production of this book. Special thanks go to Patricia M. Blackler at the Skaneateles Historical Society, mother and wife Nancy K. Williams, for putting up with hundreds of postcards floundering all over her "camp" during the summer, and to Gregory J. Alexander for his outdoor writing arena, ready refreshments, and editing skills.

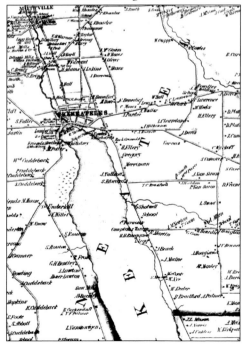

This map of Skaneateles and Skaneateles Lake was drawn in 1854.

INTRODUCTION

Skaneateles sits proudly at the foot of Skaneateles Lake. The name is said to have derived from a Native American word meaning "long lake." However, many say that the name comes from a similar word meaning "beautiful sleeping squaw," first spoken by the Onondaga Indians when they looked down the tranquil blue waters still seen today.

The first white settlers arrived in 1794 to claim lands promised to them from their efforts of fighting in the Revolutionary War. The village was officially incorporated on April 19, 1833. Skaneateles transformed from its beginnings as a working industrial town, with distilleries, mills, and carriage works, to a prosperous summer resort for the wealthy as early as the 1870s. Similarly, the lake itself has served as a resource for much sought-after ice and food and as a summer recreational area for the leisure class.

This book of postcards seeks to follow that progression by using the familiar illustrated postal note as a guide for residents and visitors alike to reveal its history and changes over time and perhaps to offer an appreciation of its remarkable past, more rich in culture and society than larger communities can claim. Even its renowned polo club was formed in 1962.

Chapter 1 highlights the interaction that Skaneateles Village has had with Skaneateles Lake, located at its edge. The images capture the early commercial buildings built on the shore, the Sherwood Inn, and the many extravagant large summer homes built in the village to take advantage of such a beautiful lake setting. Many of the former summer homes are large year-round residences enjoyed and well maintained in their historic setting by caring residents today.

The second chapter investigates two of the most photographed features of Skaneateles: its twin parks, located on the shores of the lake on either side of the commercial district on Genesee Street. The Thayer Park of today once served as the private and formal gardens of an early Skaneateles family. Clift Park, located in front of the Sherwood Inn, has served as a public meeting place and swimming spot for more than 100 years. Its westernmost portion, known today as Shotwell Park, also serves as the proud memorial site for the village's war veterans.

Revealed in chapter 3 are lake scenes sent on postcards throughout the world. Local boaters and summer residents are more than familiar with the various points that jut out into the lake with both symbolic and navigational names such as Three Mile Point. Because many of the cards sent from Skaneateles were from temporary residents, the most popular cards included the lake scenes seen herein.

Chapter 4 explores the myriad boating scenes that have captivated Skaneateles residents and visitors alike. From the introduction of steam-powered boats on the lake in 1838 through the formation of various boat-making companies in Skaneateles in the 1880s and beyond, the lake has served as an experimental resource and the site of many a regatta, rowing race, and recreational cruise. The heyday of steam-powered ships such as the *City of Syracuse,* which carried as many as 600 passengers, has to this day been re-created and maintained by the ever-popular Mid Lakes Navigation Company.

The final chapter features several of Skaneateles Lake's hotels and resorts, primarily its best known, the Glen Haven Hotel and Water Cure, on the southernmost shores. It was begun by a group of physicians who promoted the "purest body of water" in North America to attract those suffering various unexplained ailments for a variety of what might be considered today bizarre water treatments. Guests traveled to Skaneateles via the Skaneateles Railroad from Syracuse and from points all over the United States, as well as on large steamers to reach the remote location. Sadly, the hotel was torn down in 1911, but many other smaller summer resort areas and rentals still exist to this day.

One

SKANEATELES LAKESIDE VILLAGE

Since 1794, when the first settlers arrived to claim lands that were part of the Revolutionary War land grants, the village of Skaneateles (incorporated in 1833) has benefited from its unique setting at the very foot of Skaneateles Lake. As such, much of the early commerce and residential building stock of the village has focused on the lake, which offers an outstanding vista, as any current resident or visitor knows.

Although several early structures in the village still exist today, perhaps the standing authority in Skaneateles has been the Sherwood Inn, which got its beginning in 1807 as a small building on the same spot as it is today, across from the lake. Isaac Sherwood then operated it as a tavern and mail repository, for which he was paid handsomely by the federal government. It was radically expanded to its present form in 1872.

Skaneateles resident John D. Barrow was born in 1824 and moved back into the village after time spent in New York City. Here, he painted many memorable and much sought-after scenes of the lake and village. On October 8, 1900, he dedicated a gallery he had designed at the Skaneateles Library, still seen today.

Skaneateles did not become a fashionable summer resort until the Industrial Revolution of the 1870s and 1880s. It was more of a working-class town with numerous mills on the outlet, factories producing carriages, and other commerce. However, with wealth growing in Syracuse and even New York City, the village expanded rapidly with elaborate summer homes, some being built with more than 20 rooms and fireplaces too numerous to count. Many summer homes in the village were built in the 1880s and 1890s. They were intended for summer residence only and were shuttered for the remainder of the year.

Summer residences also began to extend down both sides of the lake, ranging from large country estates to small, humble cottages. Some of these were only accessible by boat, while others included vast self-sufficient farms and dairy herds. The commercial area of Skaneateles has always had an interesting juxtaposition on the lake, with the backs of most businesses on Genesee Street on the lake itself. Many visitors today are pleasantly surprised to catch a glimpse of the lake from the rear window of a gift shop or alley.

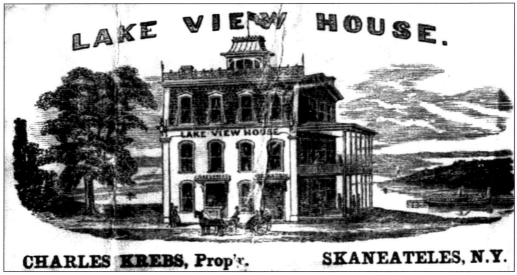

Perhaps one of the first structures built along Genesee Street to take advantage of lake scenes is the Lake View House, which still remains to this day. It was built in 1874–1875 by Charles Krebs, father of Frederick Krebs of the famed local restaurant. (Courtesy Skaneateles Historical Society.)

This greeting card shows scenes of Carpenter's Falls, the lake, and Genesee Street.

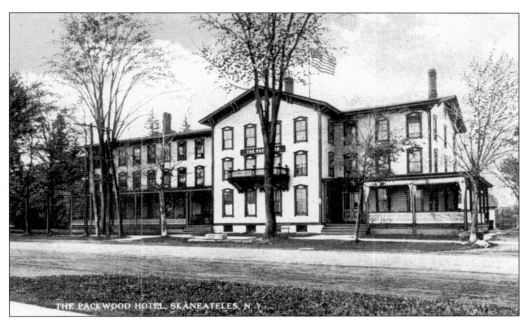

The building that originally occupied the site of today's Sherwood Inn, located downtown across from the lake, was built in 1807 and was operated by Isaac Sherwood as a tavern and mail depository.

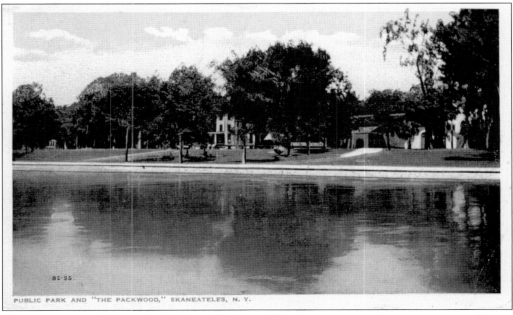

This 1921 postcard shows the Packwood House with what appears to be a new stone wall, very calm waters, and buildings to the right, which no longer exist.

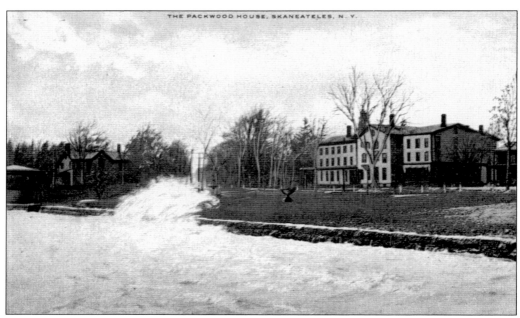

Skaneateles Lake has always been a lake that can change from placid to ferocious in a matter of minutes, as illustrated by this scene from a postcard mailed in 1908.

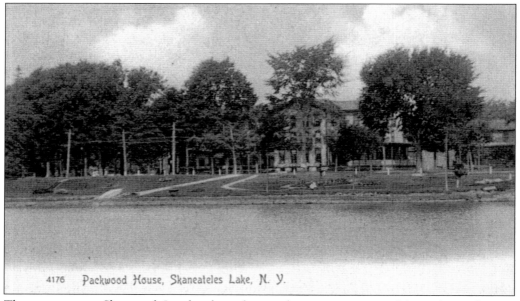

The ever-present Sherwood Inn has been known by many names and has witnessed many expansions and alterations since being built in 1807. Its first owner, Isaac Sherwood, was paid more than $60,000 a year from 1833 to 1837 for the many central New York post office routes that relied on his tavern as a repository.

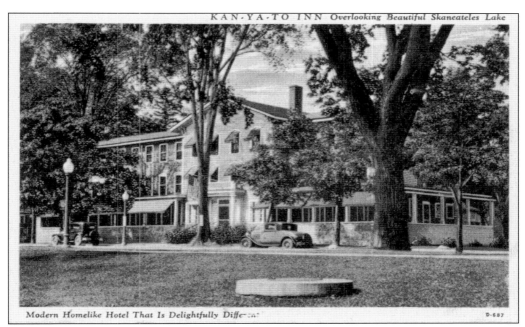

Modern Homelike Hotel That Is Delightfully Diffe~:n:

D-687

The Sherwood Inn was purchased by Alfred Lamb in 1839 and was vastly enlarged and renamed Lamb's Inn. In the years that followed, it was also known as Houndayaga House and the Union Hotel. Skaneateles town meetings were even held there from 1843 to 1855.

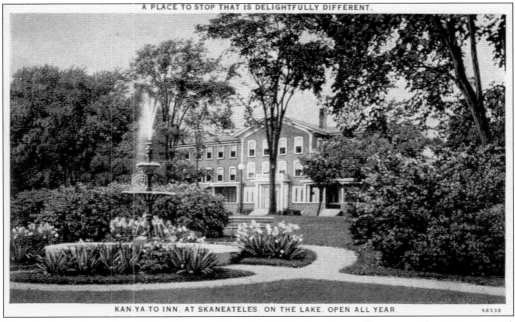

A PLACE TO STOP THAT IS DELIGHTFULLY DIFFERENT.

KAN-YA-TO INN, AT SKANEATELES, ON THE LAKE, OPEN ALL YEAR. 98538

John Packwood purchased the Sherwood Inn in 1865, when it was known as the Union Hotel. A prominent local carriage maker, Packwood changed its name to the National Hotel. In 1868, it became the Packwood House, a name that would be used for the next 50 years.

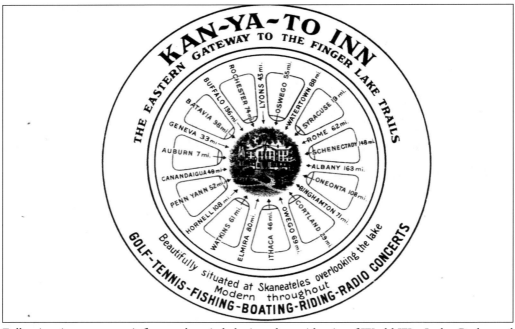

Following its use as an influenza hospital during the epidemic of World War I, the Packwood House was renamed the Kan-Ya-To Inn in 1922.

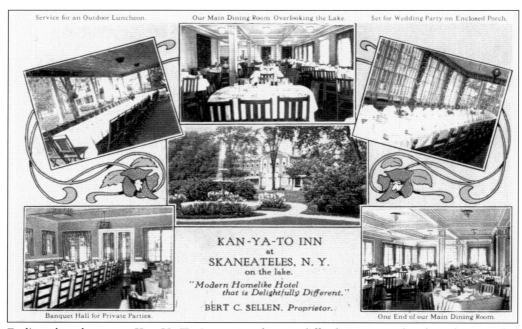

Feeling that the name Kan-Ya-To Inn not only was difficult to remember but also sounded foreign, owner Chester Coats changed the name of the inn back to its original name, the Sherwood Inn, in 1942.

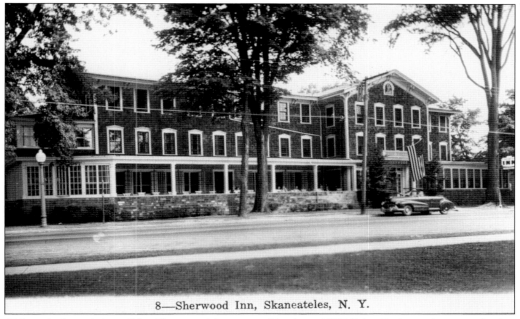

8—Sherwood Inn, Skaneateles, N. Y.

Although the origins of the Sherwood Inn extend back to 1807, John Packwood removed what was the original portion of the tavern in 1872 to expand and improve the facility.

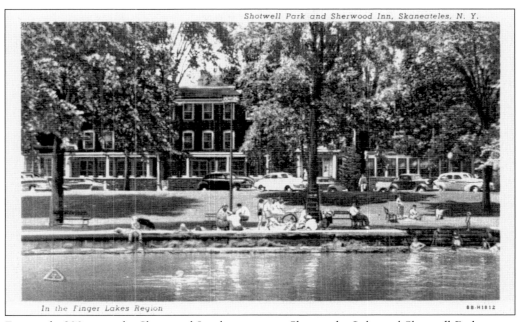

Shotwell Park and Sherwood Inn, Skaneateles, N. Y.

In the Finger Lakes Region

8B-H1812

For nearly 200 years, the Sherwood Inn has overseen Skaneateles Lake and Shotwell Park.

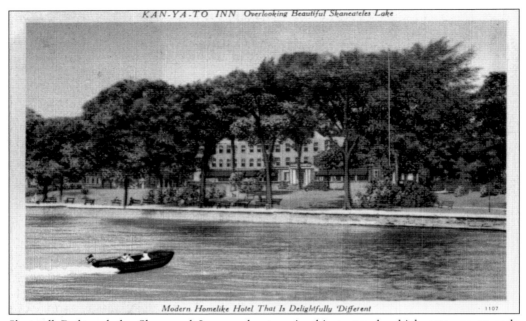

Shotwell Park and the Sherwood Inn can be seen in this postcard, which captures an early motorboat speeding its way toward the village center.

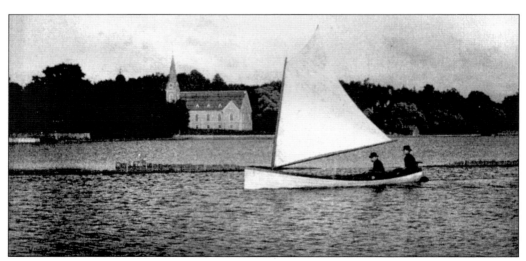

William Seward Jr., son of the U.S. secretary of state under Pres. Abraham Lincoln, took this rare image of a wooden sailboat at the village edge in the 1870s. (Courtesy Seward House Archives.)

Artist John Barrow spent much of his life painting Skaneateles Lake scenes. He was born in 1824 and started painting at the age of 14.

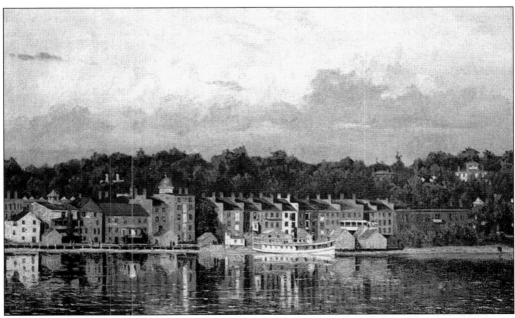

Following the time he spent in New York City from 1856 to 1876, John D. Barrow returned to Skaneateles, where he resided at 34 State Street beginning in 1855. He painted this scene of Skaneateles *c.* 1882.

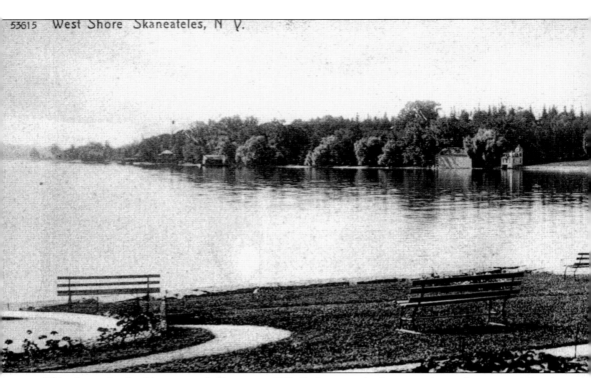

This dramatic double postcard illustrates Clift Park, named after prominent farmer and local businessman Joab Clift, in the western portion of the village. Located in front of the Sherwood

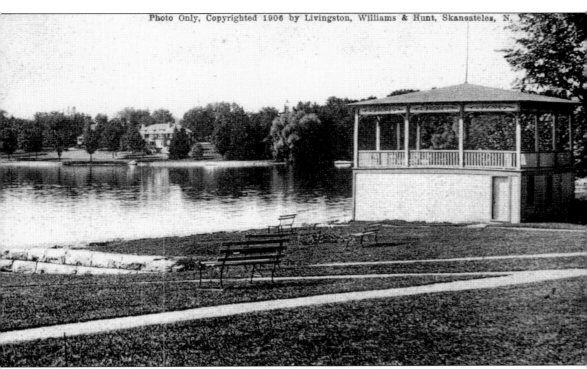

Inn at the beginning of the 20th century, it featured an ornate bandstand but little vegetation. Homes along West Lake Road in the village can be seen in the background.

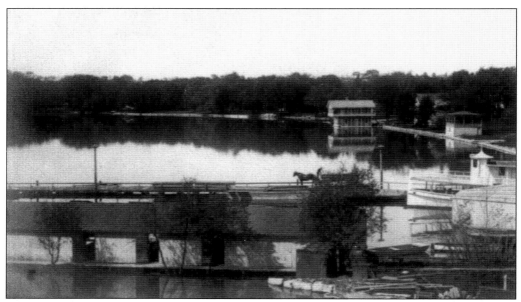

This image of the pier and Shotwell Park shows one of the many steamships that traversed the lake, as well as a horse on the pier, patiently waiting its owner's return. (Courtesy Skaneateles Historical Society.)

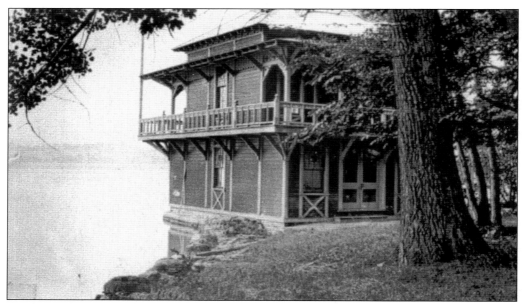

This elegant boathouse was built for the Waller family and was later adapted to be used as a private home along West Lake Street. It is still in existence today. (Courtesy Skaneateles Historical Society.)

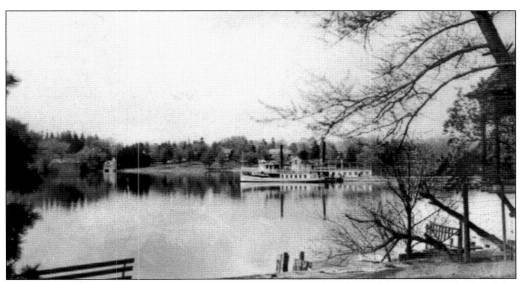

Patrons of lakeside hotels and guests visiting private homes along the lake used one of the many steamships that traversed the waters, seen here docked along the pier at Clift Park. (Courtesy Skaneateles Historical Society.)

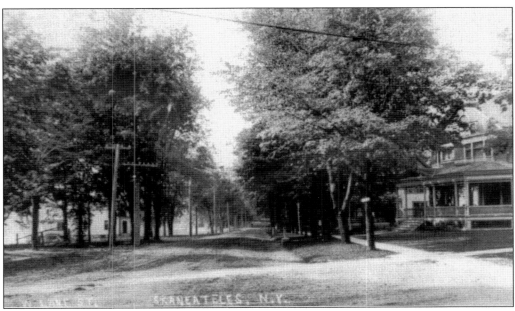

West Lake Street has always been a desirable place to live in Skaneateles due to its close proximity to the lakeshore in the village. West Lake Street is seen here at its intersection with Genesee Street. (Courtesy Skaneateles Historical Society.)

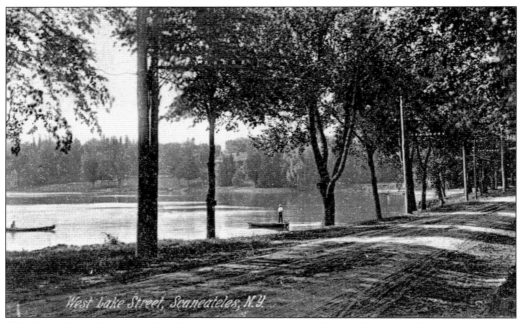

West Lake Street is captured in this postcard when it appeared as a rather rural-looking road paved with dirt.

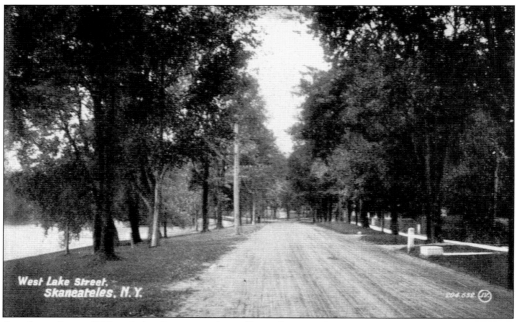

Another view of West Lake Street in the village shows a large stone step on the right, used for dismounting a horse-drawn carriage. The stone pylon next to it was used for hitching one's horse.

Located along West Lake Street, this elegant if not overdone garden on the lake belonged to A.H. Schwarz.

This illustration of West Lake Street, looking north, was taken long before houses were built to the right along the shore, on what had originally been the yards of the older homes located to the left. (Courtesy Skaneateles Historical Society.)

This rural-looking image along West Lake Street in the village would not be recognizable today, as the street is now lined with elegant homes. (Courtesy Skaneateles Historical Society.)

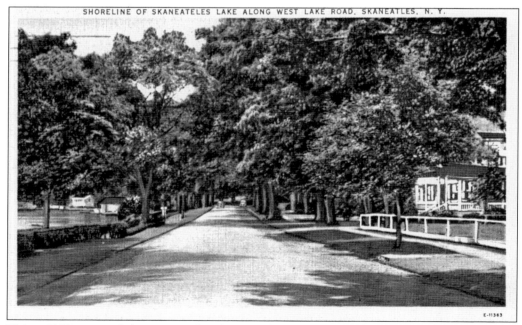

SHORELINE OF SKANEATELES LAKE ALONG WEST LAKE ROAD, SKANEATLES, N. Y.

E-11363

This c. 1950s postcard shows a tree-lined West Lake Street and a glimpse of the lake.

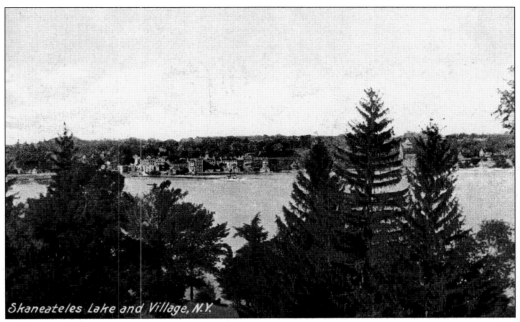

Skaneateles Lake and Village, N.Y.

This view from Roosevelt Hall shows the village of Skaneateles, long associated with the lake itself.

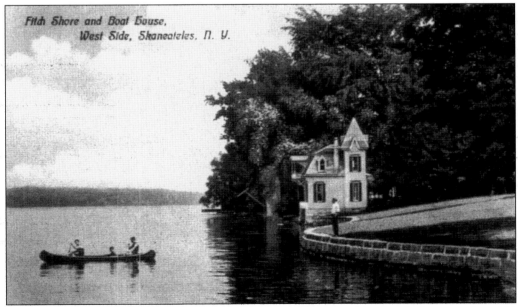

*Fitch Shore and Boat House,
West Side, Skaneateles, N. Y.*

This elegant French mansard–style boathouse has served as a local landmark for more than 130 years. It is located along West Lake Street. (Courtesy Skaneateles Historical Society.)

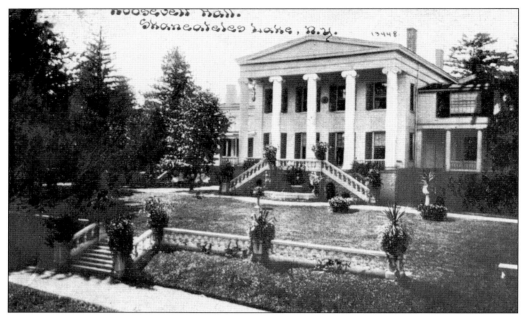

Roosevelt Hall was erected in 1839 by Col. Richard DeZeng and was then called Lake Home. Its Greek Revival facade is the same on the street side and on the side facing the lake (shown here).

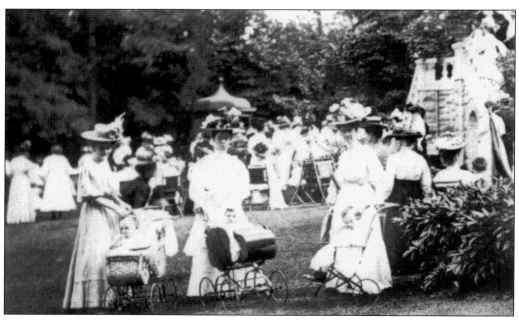

These elegantly dressed Victorian women are enjoying the lake lawn of Roosevelt Hall, purchased by Samuel Roosevelt in 1899. He was an artist, a merchant, and a relative of Franklin D. Roosevelt, who later visited the house. (Courtesy Skaneateles Historical Society.)

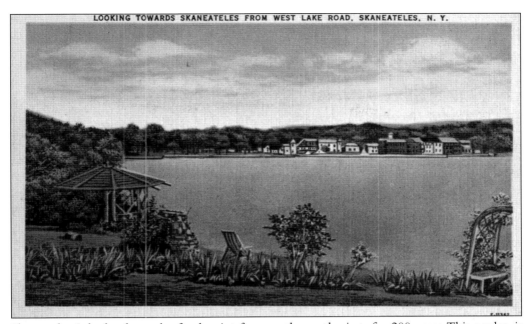

Skaneateles Lake has been the focal point for countless enthusiasts for 200 years. This garden is typical of those found along its shores.

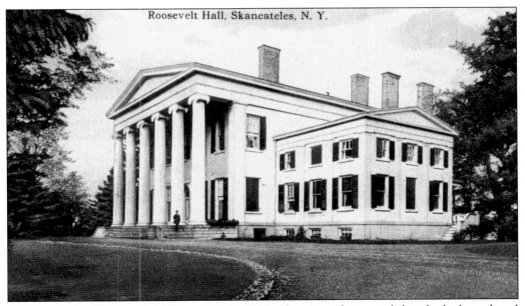

Roosevelt Hall, Skaneateles, N. Y.

This postcard of Roosevelt Hall was sent in 1919, when its author noted that she had purchased a "lovely hat found in a window for $1.50." It was apparently trimmed in green, which matched the sweater she was then wearing.

27

Skaneateles Lake, N.Y.

A familiar image to any visitor or resident is this scene along West Lake Street in the village, caught here on a still morning.

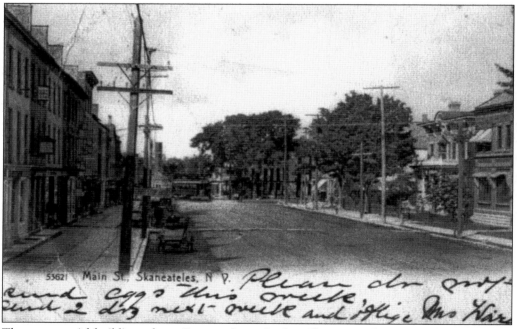

53621 Main St., Skaneateles, N.Y.

The commercial buildings along Genesee Street in the village are rather unusually designed in that the backs of the structures face the lake. Many once had icehouses and boathouses used for commercial purposes. (Courtesy Skaneateles Historical Society.)

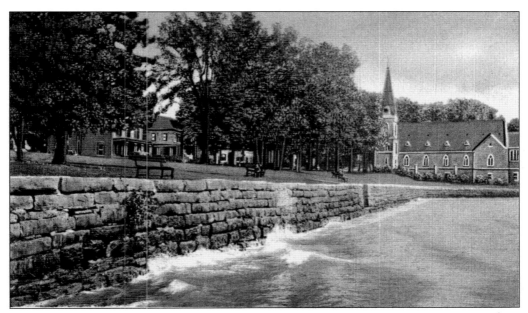

Many village homes have a view of the lake, including these located across the street from Thayer Park.

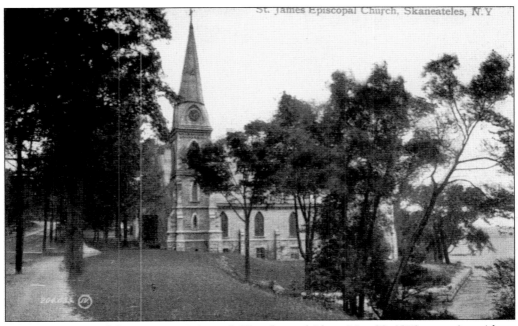

The cornerstone of the St. James Episcopal Church was laid on May 30, 1873, on a site with an outstanding view of the lake. Note the dirt surface on Genesee Street and the non–landscaped Thayer Park when this postcard was sent in 1912.

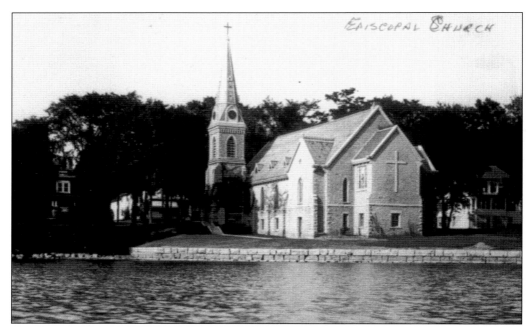

Several of Skaneateles's earliest pioneers organized St. James Episcopal Church in 1816. In 1827, they built their first church building, just to the west of the present-day church. (Courtesy Skaneateles Historical Society.)

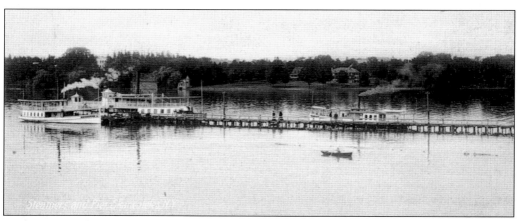

At the pier in Skaneateles, several steamers wait, ready to transport their passengers to hotels and private homes to the south.

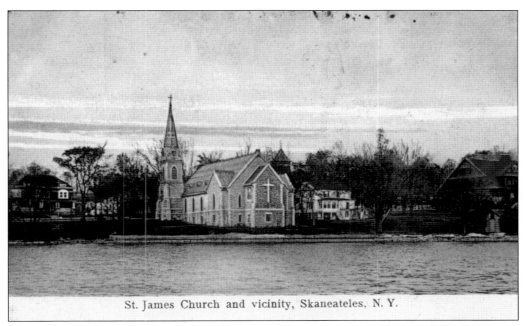

St. James Church and vicinity, Skaneateles, N. Y.

The landmark clock tower on St. James Episcopal Church contains a clock made by E. Howard of Boston and a McNeely bell made in Troy in 1893.

This image of Thayer Park was taken when two large, overgrown planters enhanced the steps to the lake. (Courtesy Skaneateles Historical Society.)

The rear yard and lakeshore can be seen here from the home at 100 East Genesee Street. The house was built as a large summer home for Joseph C. Willets in 1883. (Courtesy Skaneateles Historical Society.)

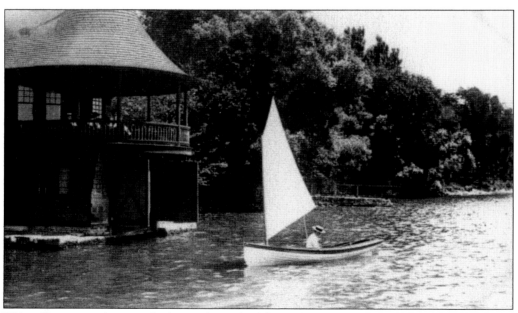

This sailboat was photographed near the end of the 19th century in front of one of the elegant boathouses in the village. (Courtesy Skaneateles Historical Society.)

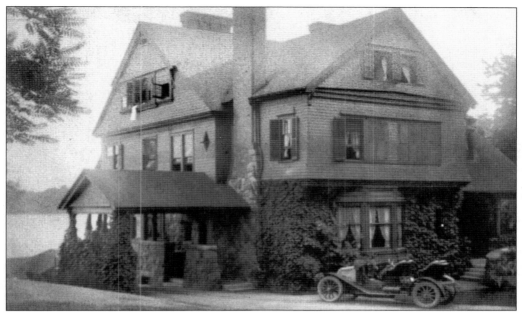

The house at 100 Genesee Street was known as the Boulders due to its limestone first floor. Built in 1883, it was later purchased by Sen. Frances Hendricks in 1918. It featured an elaborate boathouse on the lake, which remains to this day. (Courtesy Skaneateles Historical Society.)

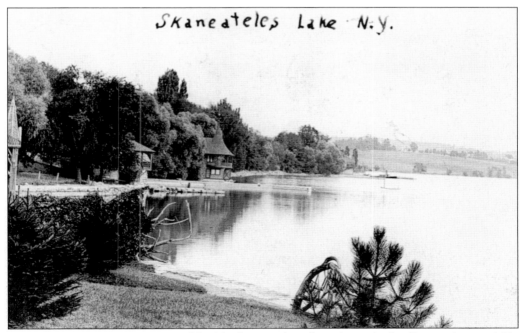

This view of the eastern portion of the lakeshore in the village shows, in the distance, how quickly the shore was characterized by farms and pastureland as it left the village.

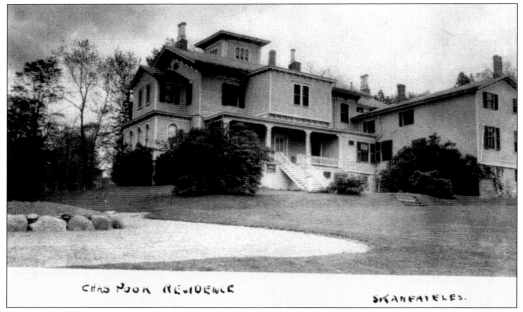

CHAS POOR RESIDENCE SKANEATELES.

This village house at 104 East Genesee Street also featured a large rear yard on the lake. Known as Willowbank, the house was enlarged in 1830 from a small frame house that had been built in 1820. It was enlarged again in the 1880s. (Courtesy Skaneateles Historical Society.)

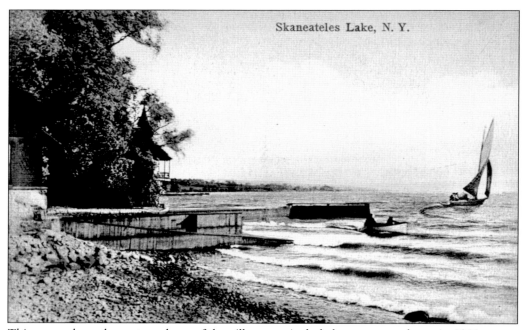

Skaneateles Lake, N. Y.

This scene along the eastern shore of the village was included on a postcard sent in 1911.

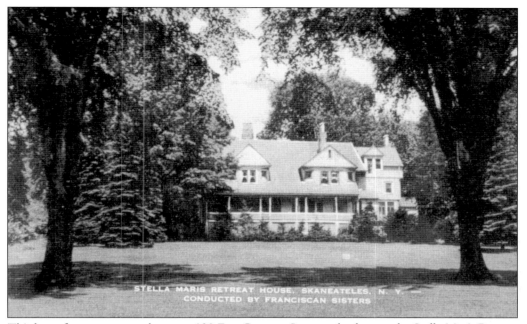

This large former summer home at 130 East Genesee Street today houses the Stella Maris Retreat Center, with an expansive lawn that stretches down to the lake.

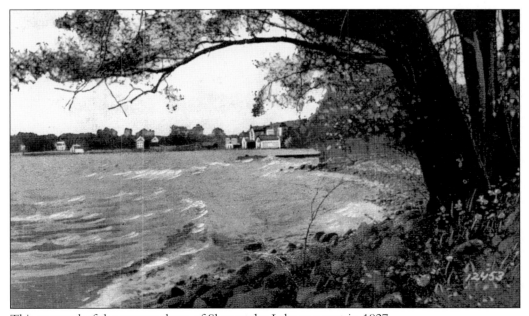

This postcard of the eastern shore of Skaneateles Lake was sent in 1927.

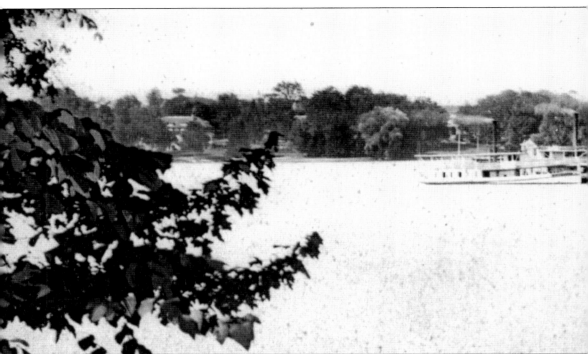

Three steamers can be seen here at the Skaneateles Pier, including the *City of Syracuse*, built by

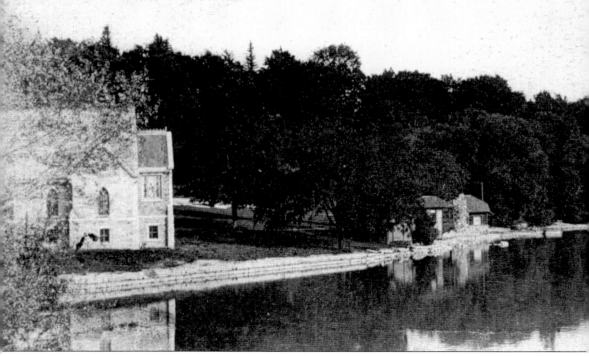

The lovely eastern shore of the village is captured in this elongated postcard. Note the farms that

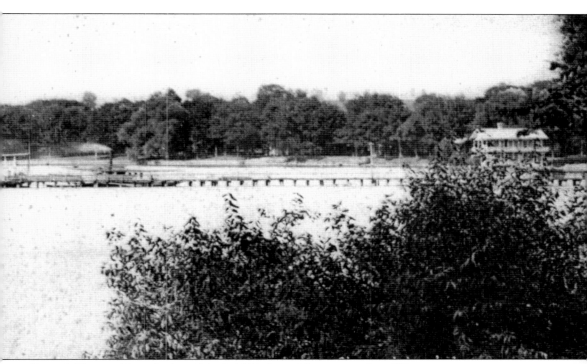

Samuel Allen and launched on July 6, 1901. It could accommodate 600 passengers.

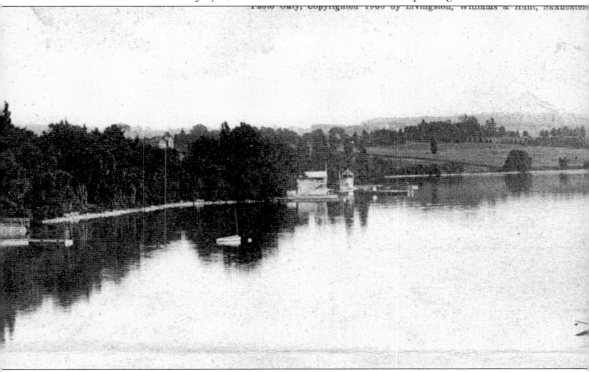

extend to the lakeshore to the right, just outside the village limits.

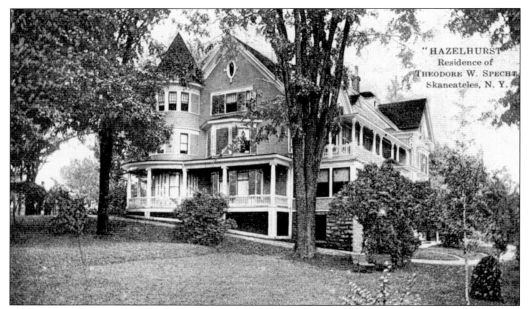

In 1864, William Loney built this imposing 25-room summer home at 150 East Genesee Street, which featured an enormous lawn that stretched to the lake. Theodore Specht became this home's owner in the 1880s and renamed it Hazelhurst. Later, the vast lawn was developed as Lake View Circle, with about 30 homes that share a common lakefront access.

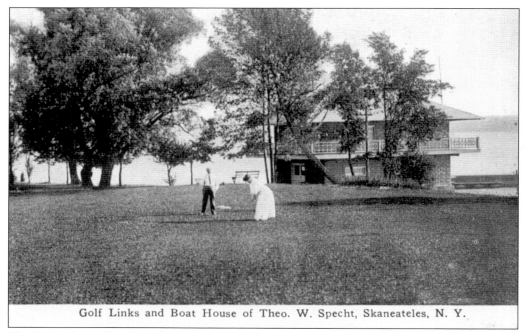

Golf Links and Boat House of Theo. W. Specht, Skaneateles, N. Y.

The lawn of Hazelhurst was large enough to be used for a game of golf.

Two

SKANEATELES PARKS

One might assume that a village situated on the shore of a lake as dramatic as Skaneateles would have taken immediate advantage of its major resource. In fact, Skaneateles—focused as it was on industry on the outlet and commerce on the main street—began with buildings that faced away from the lake. However, the village did have the Lakeview House and the Sherwood Inn, two early attempts to take advantage of the lakeshore location.

The park across from the longstanding Sherwood Inn has been used for well over 100 years as a place to congregate. People once waited there for the many steamboats that left the adjacent pier to points south on the lake or to listen to a band concert on the bandstand that once stood on its western edge. The park was later named Clift Park, after Joab Lawrence Clift (born in 1818), a founder of the Skaneateles Savings Bank who sold the land to the village and donated an elaborate fountain that graced the park for years.

Thayer Park, at the eastern edge of the commercial strip, was not given to the village of Skaneateles until 1922, when the granddaughters of Joel Thayer provided the land. Before that date, it had been a meticulously maintained garden associated with the spectacular house of Joel Thayer, located across East Genesee Street. It, too, had a vast garden with gazebos, terraces, and fountains that he expanded in 1862, when he remodeled the house with ornate ironwork and the fence still seen today. The land across the street eventually deteriorated (as several of the following images will attest) into an area overrun with vegetation and weeds.

The westernmost portion of Clift Park on the east side of the commercial strip was expanded by purchasing adjoining residential property in 1936 and was named Shotwell Park. It was made possible by a gift of $15,000 in 1926 from William Shotwell's widow, Florence Shotwell, to purchase the land and establish a living memorial to her husband, a prominent local businessman who died in 1922 in his home on West Lake Street. It was later modified to accommodate a memorial for Skaneateles residents who lost their lives during World Wars I and II and the Korean and Vietnam conflicts.

Both parks are today a delight for any visitor to Skaneateles, a place of meeting, recreation, sunbathing, and even a simple reading of the *Skaneateles Press* on a cool summer evening.

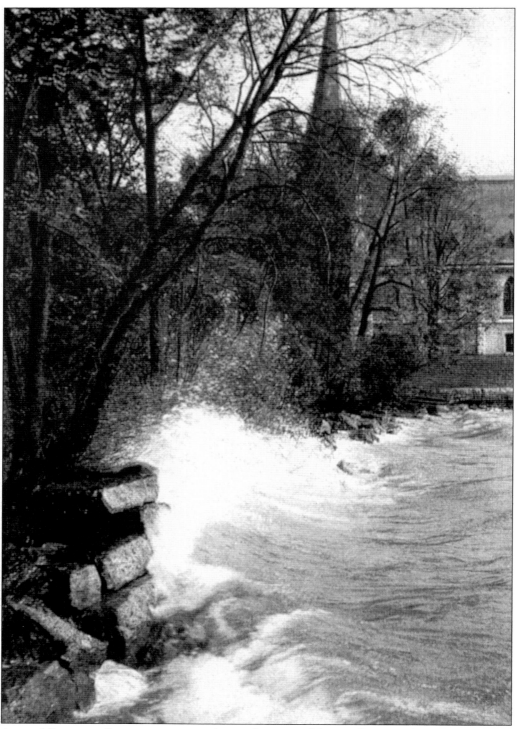

A crumbling sea wall, overgrown vegetation, and an angry lake are all captured in this postcard of what today is known as Thayer Park in the village.

Thayer Park was given to the village in 1922 by Eva and May T. Webb to commemorate their grandfather Joel Thayer. (Courtesy Skaneateles Historical Society.)

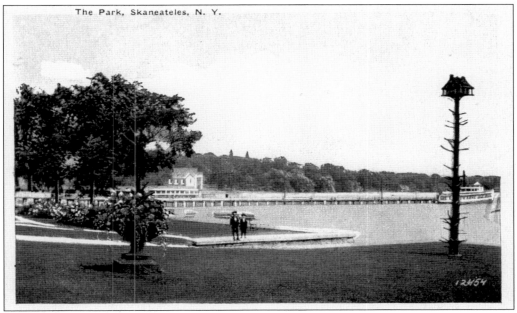

Two lads stand on the sea wall in Clift Park. In the right foreground is an early birdhouse, and in the right background at the old wooden pier is a steamer.

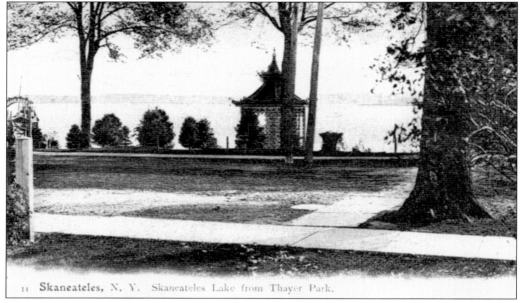

The area that is now Thayer Park was a private garden of the Thayer home, located across the street and known for decades as the Bush Funeral Home.

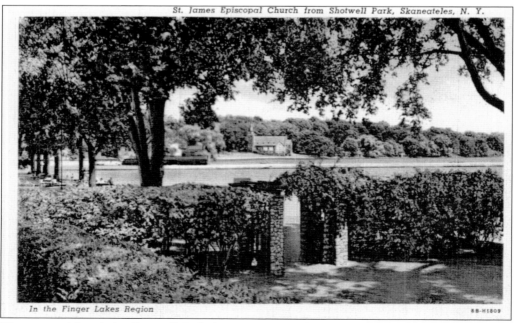

The memorial arch in Shotwell Park is overgrown with vines. Thayer Park is to the left of St. James church, in the background.

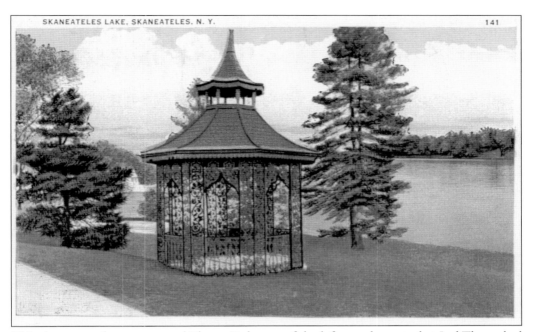

This elegant gazebo once graced Thayer Park, one of the leftover elements that Joel Thayer had in what was then his private garden.

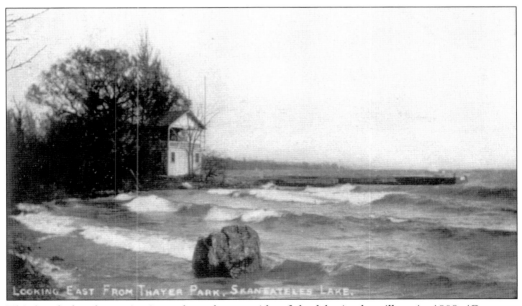

This lonely boathouse is pictured on the east side of the lake in the village in 1909. (Courtesy Skaneateles Historical Society.)

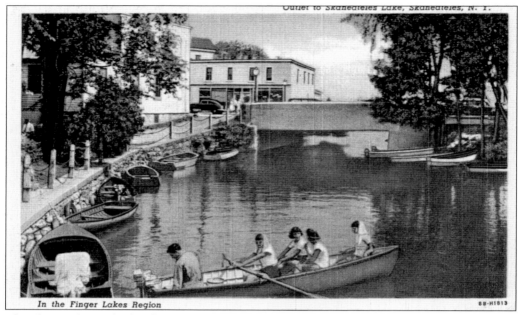

In the Finger Lakes Region

The Skaneateles outlet has for years hosted a variety of small watercraft, as it does today.

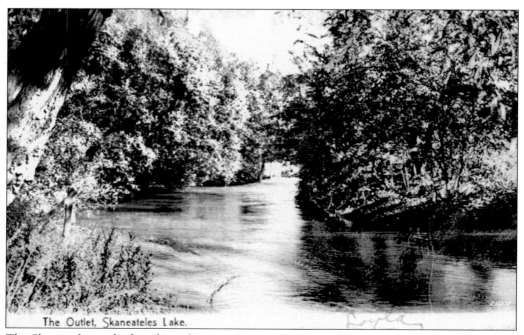

The Outlet, Skaneateles Lake.

The Skaneateles outlet has always been an important source of power for myriad industries and mills and has remained in a natural state.

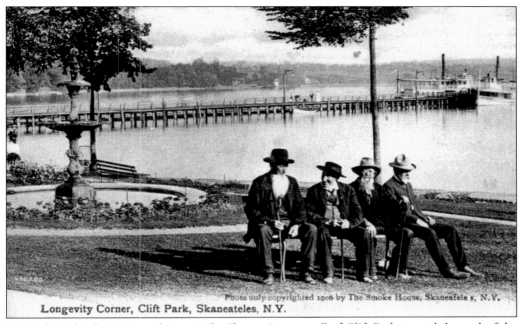

Longevity Corner, Clift Park, Skaneateles, N.Y.

These four elderly men are shown at the "longevity corner" of Clift Park toward the end of the 19th century.

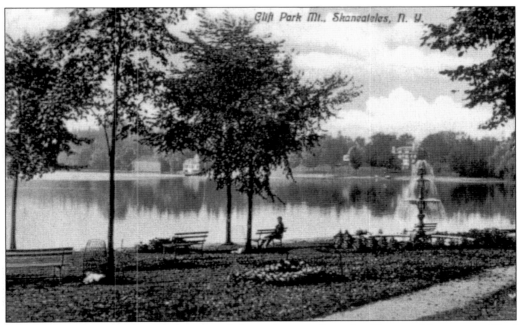

Clift Park Mt., Skaneateles, N. Y.

The elegant cast-iron fountain that graced the park across from the Sherwood Inn was a gift of Joab Clift. The donation resulted in the naming of the park in his honor. (Courtesy Skaneateles Historical Society.)

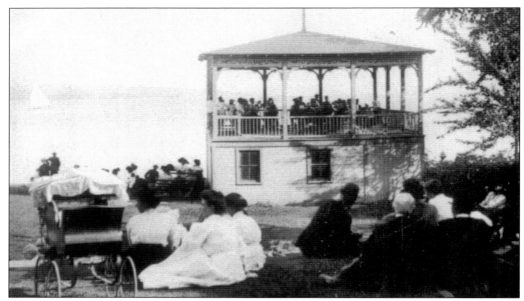

Victorian residents gather in front of the band shell for a summer concert while a sailboat slowly passes in the calm waters behind. (Courtesy Skaneateles Historical Society.)

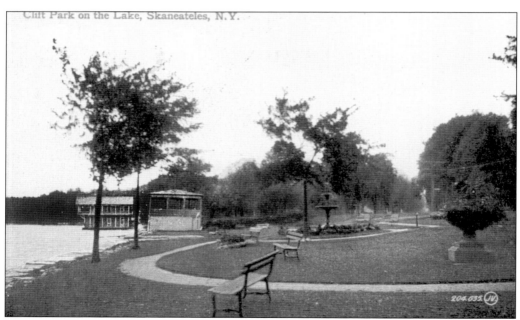

Clift Park on the Lake, Skaneateles, N.Y.

In the early part of the 20th century, Clift Park featured large urns filled with flowers, winding paths, and a refreshing fountain.

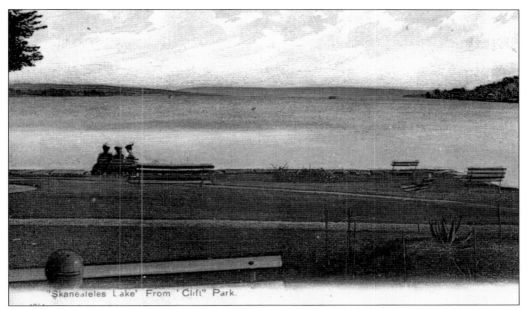

"Skaneateles Lake" From "Clift" Park.

Three Victorian women enjoy an evening sunset at Clift Park. Note in the foreground a newly planted yucca plant protected by a wire fence.

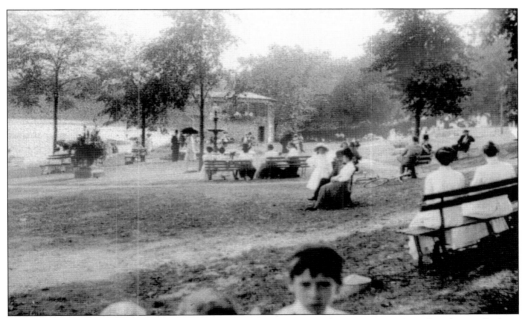

Clift Park is crowded with residents and visitors who, perhaps, are waiting for the arrival or departure of one of the many steamships at the pier. (Courtesy Skaneateles Historical Society.)

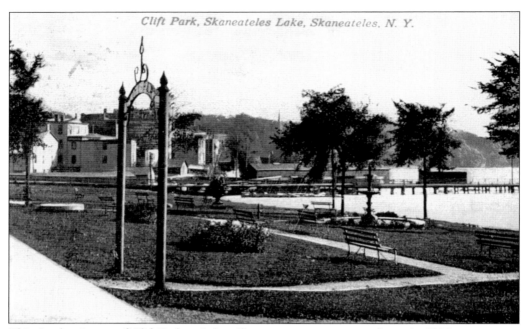

Clift Park, Skaneateles Lake, Skaneateles, N. Y.

This timeless image of Clift Park and the village appears on a postcard sent in 1912.

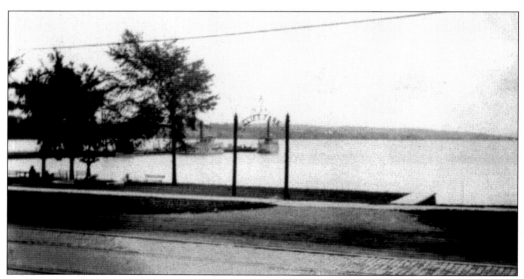

In this view of Clift Park, the arched sign frames one of the steamers at the pier. In the foreground is the old Auburn–Syracuse rail line that went through Skaneateles along Genesee Street. (Courtesy Skaneateles Historical Society.)

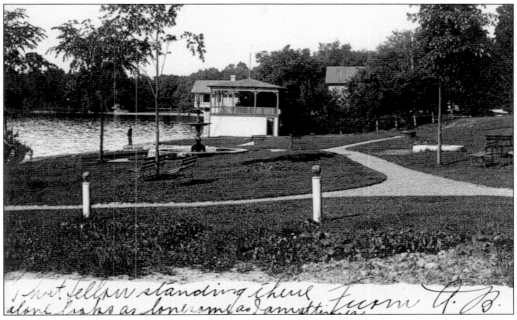

This idyllic scene includes a rather stark note from the sender: "That fellow standing there alone looks as lonesome as I am at times." It was postmarked 1905.

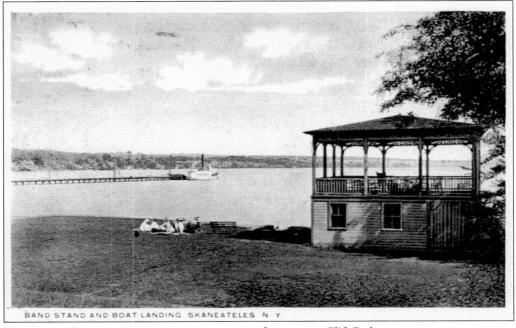

BAND STAND AND BOAT LANDING. SKANEATELES. N.Y.

These picnickers are enjoying a sunny summer afternoon at Clift Park.

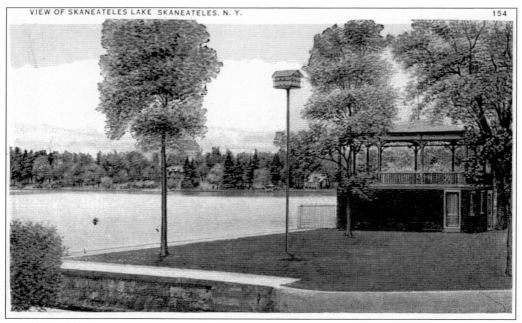

A multilevel birdhouse had been added to the features of Clift Park by the time this postcard was sent in 1938.

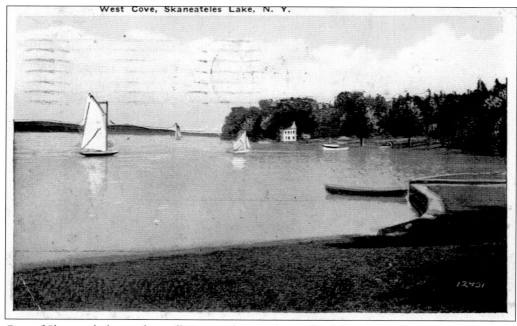

One of Skaneateles's wooden sailboats can be seen here off Clift Park.

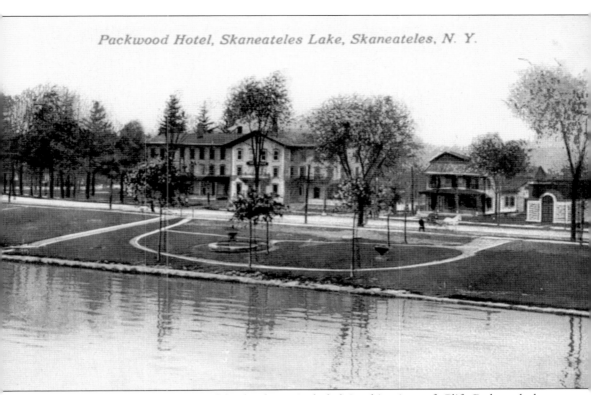

Packwood Hotel, Skaneateles Lake, Skaneateles, N. Y.

Small saplings and a very high lake level are included in this view of Clift Park and the Packwood Hotel (now the Sherwood Inn). The buildings to the east of the inn have long since been demolished.

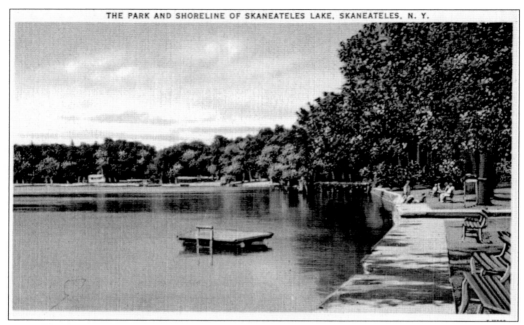

A crude raft floats in the cove off Clift Park, which today is still a community swimming center enjoyed by many.

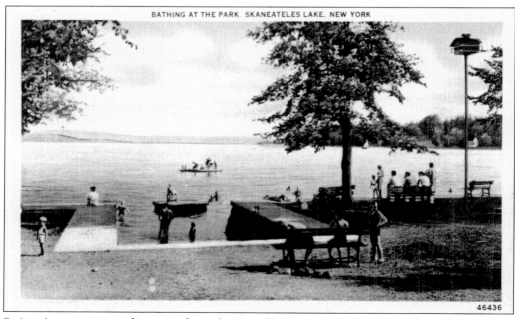

46436

Swimming was apparently so popular at the time this postcard was issued that the sunbathers have worn the surrounding lawn bare.

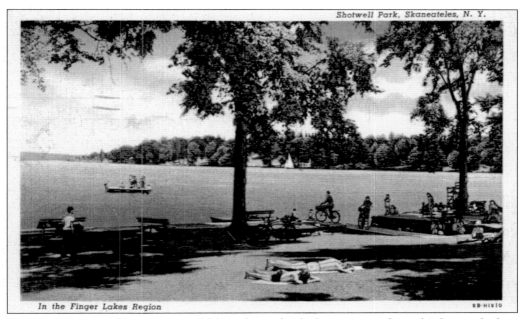

Shotwell Park, Skaneateles, N. Y.

In the Finger Lakes Region

Victorian women of long ago would have been shocked to witness these shirtless sunbathers enjoying themselves in Shotwell Park in the 1940s.

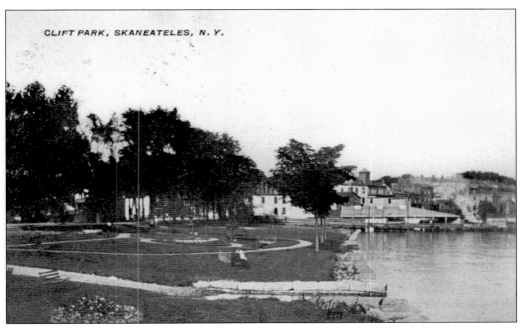

CLIFT PARK, SKANEATELES, N. Y.

This image of Clift Park and the village beyond was sent on a postcard dated 1930.

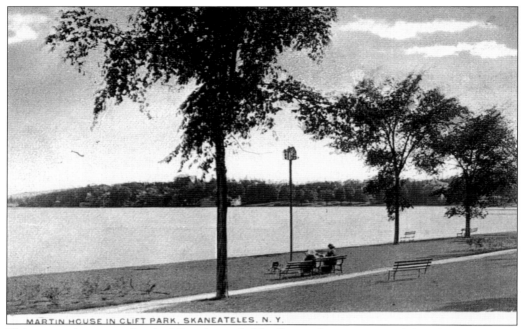

MARTIN HOUSE IN CLIFT PARK, SKANEATELES, N. Y.

This postcard captures the tiny Victorian-styled birdhouse for martins in Clift Park.

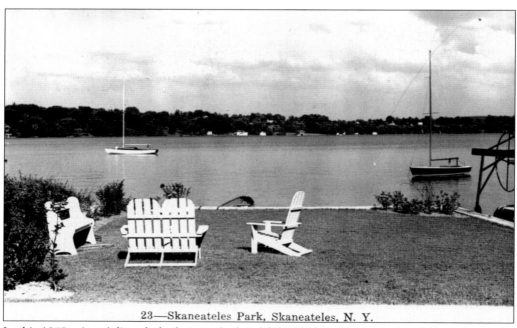

23—Skaneateles Park, Skaneateles, N. Y.

In this 1960s view, Adirondack chairs and a boatlift highlight a private park on West Lake Street.

54

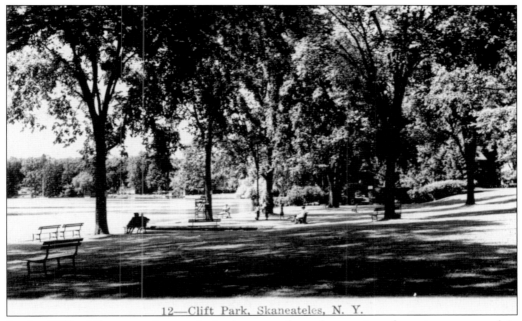

12—Clift Park, Skaneateles, N. Y.

In the 1960s, fully matured trees shade the area where the cast-iron fountain once stood in Clift Park.

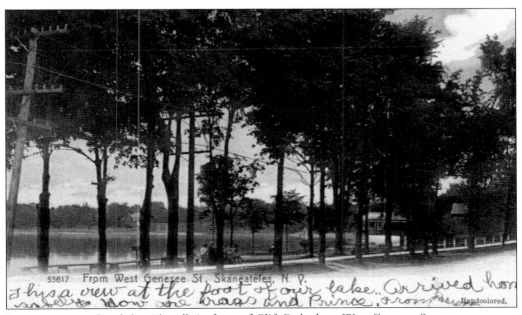

53617 From West Genesee St, Skaneateles, N. P.

This is a view at the foot of our lake.. Arrived hom.. now one tree and Prince.. Handcolored.

Large trees once lined the sidewalk in front of Clift Park along West Genesee Street.

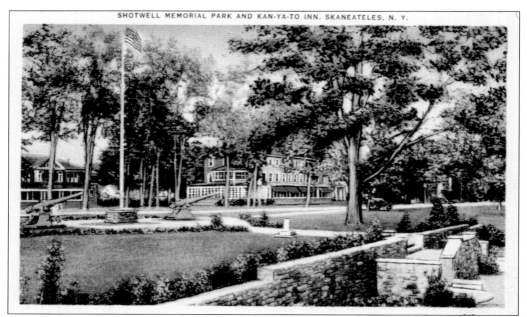

Shotwell Memorial Park was created on the western portion of Clift Park and was named after William Jenkins Shotwell, a lifelong resident and prominent businessman involved in the ice, hardware, furniture, and real estate business.

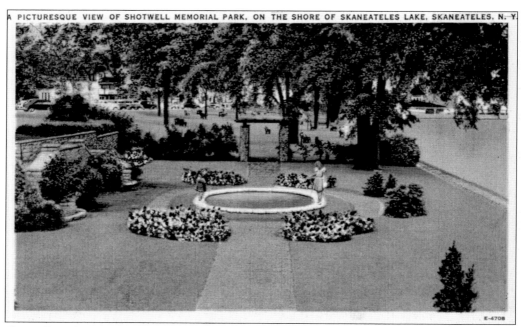

E-4708

Shotwell Park, made possible by a $15,000 gift from Florence Shotwell, was dedicated on Memorial Day of 1936.

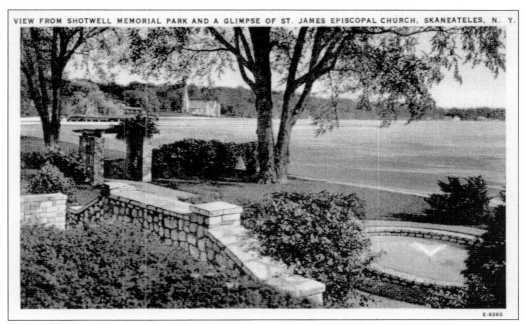

E-8080

Shotwell Park featured a memorial to those Skaneateles residents who died in World War I. It later carried the names of those who lost their lives in subsequent conflicts.

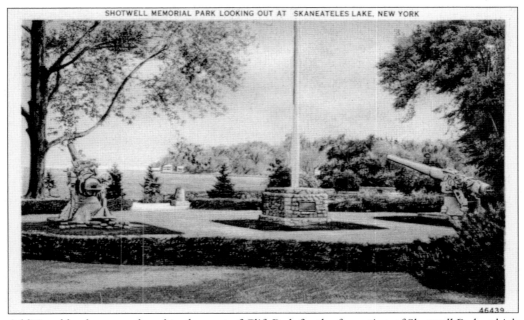

SHOTWELL MEMORIAL PARK LOOKING OUT AT SKANEATELES LAKE, NEW YORK

46439

Additional land was purchased to the west of Clift Park for the formation of Shotwell Park, which features a flagpole, heavy artillery field guns, and memorial plaques.

The two bronze busts in Shotwell Park were sculpted by Walter K. Long.

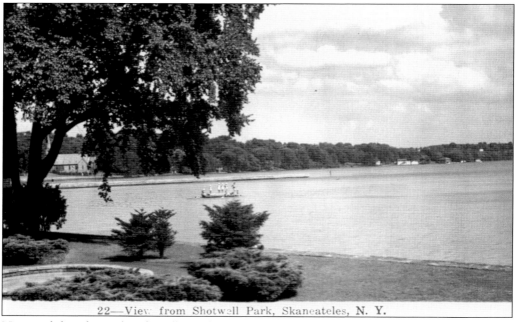

22—View from Shotwell Park, Skaneateles, N. Y.

Not much has changed in the village of Skaneateles since this view from Shotwell Park was taken for a 1960s-era postcard.

Three

LAKE SCENES

With its length of 15 miles and its width of more than a mile at various points, Skaneateles Lake sets the background for more than a few spectacular lake scenes and activities. In fact, following a round-the-world trip, Secretary of State William Seward, a native of Auburn, declared it "the most beautiful body of water in the world."

Its glacial origins and depth of 350 feet contribute to its deep blue waters, commonly reflecting the rolling hills and gently sailing boats on its surface. The water has been known to be so clear throughout history, in fact, that the city of Syracuse began using it as a source in 1893, following a five-year dispute. Skaneateles Lake continues to serve that function today, with the water flowing by gravity through dual pipes northeastward to Syracuse.

The lake's various points have been known by nautical terms, like Ten Mile Point, as well as by the names of owners or natural features, like Carpenter's Point. For centuries, the lake has had picturesque farms lining the shore, some of which remain today. Summerhouses, large and small, have been captured on postcards throughout time.

Out on the water, numerous steamboats carried passengers to and from the village to shorefront resorts and homes, and avid sailors tested and raced leisure boats, watched by spectators and tourists onshore.

Sailing, canoeing, racing, water-skiing, and motorboating have long been a way of life for area residents, as has the Skaneateles Country Club, first built at its current location in 1917. There, golfers and members have watched regattas and races on the lake ever since.

Over the years, the small hamlets, such as Mandana, New Hope, Borodino, and Spafford, have grown into year-round villages, with boatlifts and fine views of the lake.

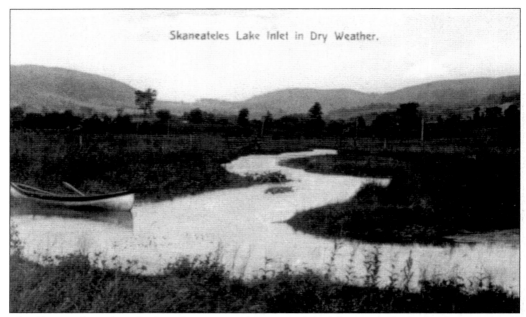

The Skaneateles Lake inlet is at the very southern tip of the lake. From the look of it, one would never guess that it empties into a lake 15 miles long and 350 feet deep. (Courtesy Skaneateles Historical Society.)

This view, taken from some distance down the west shore, shows the Skaneateles waterfront, the pier, a steamer, and a boathouse. The postcard was mailed in 1930.

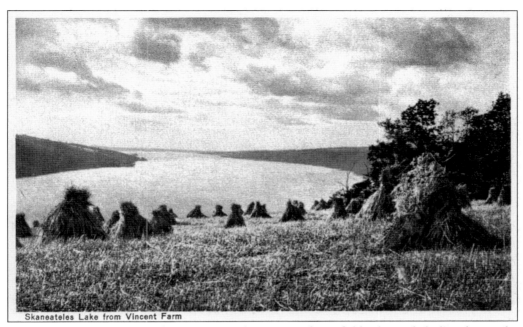

Skaneateles Lake from Vincent Farm

This postcard was produced at a time when many farm fields descended directly to the lakeshore.

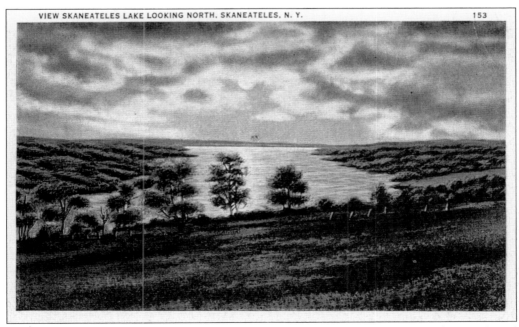

In this scene, similar to the one above, the artist has taken a few liberties with the clouds and reflections, considering that the view is looking north.

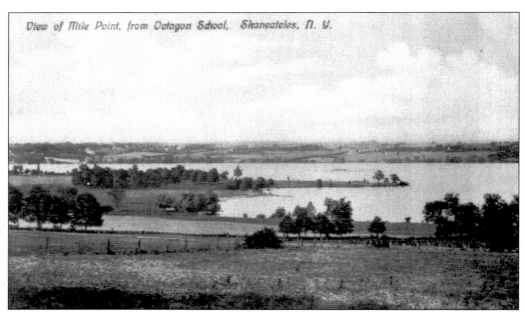

View of Mile Point, from Octagon School, Skaneateles, N. Y.

This view of One Mile Point shows how little the shore had been developed south of the village at the beginning of the 20th century. (Courtesy Skaneateles Historical Society.)

Three Mile Point Skaneateles Lake.

Three Mile Point, today full of year-round homes and cottages, featured just this large summer camp *c.* 1910.

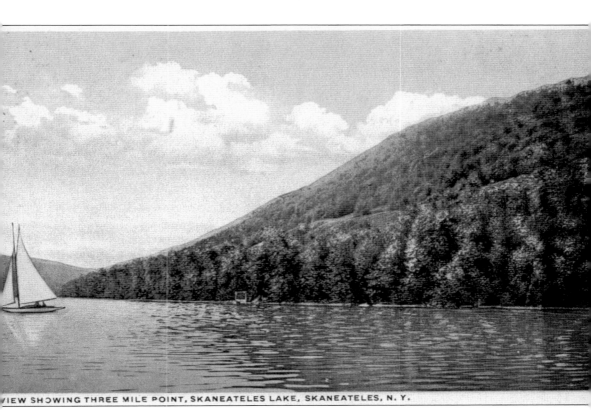

VIEW SHOWING THREE MILE POINT, SKANEATELES LAKE, SKANEATELES, N. Y.

A sailboat ventures out near Three Mile Point in the 1940s.

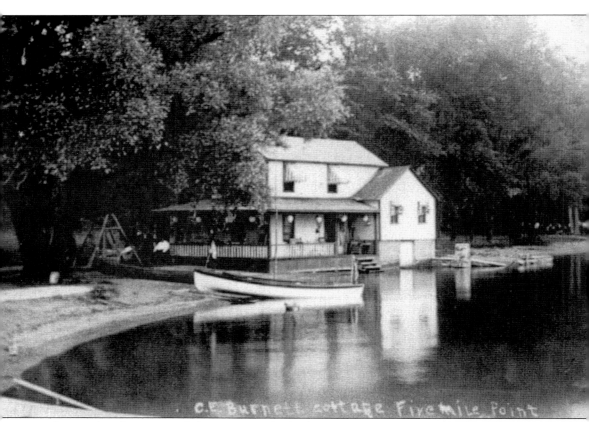

A man by the name of C.E. Burnett built this summer cottage on Five Mile Point. The cottage conveniently had a boathouse built into its basement level. (Courtesy Skaneateles Historical Society.)

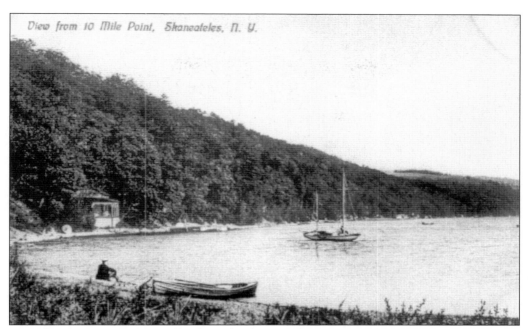

A small summer cottage is visible along the shore in this postcard of Ten Mile Point. (Courtesy Skaneateles Historical Society.)

This image of Ten Mile Point was sent with this message: "It's raining like suds, but we're still having fun."

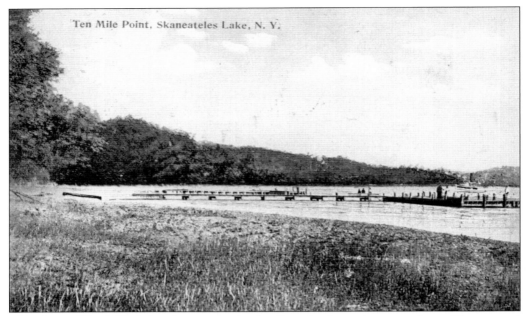

This view of Ten Mile Point shows a massive landing pier for various steamboats. The postcard was mailed in 1911.

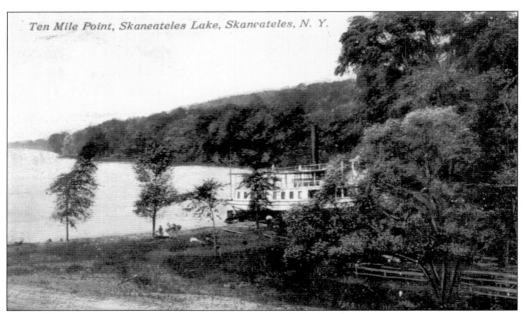

One of the large steamers can be seen here at Ten Mile Point.

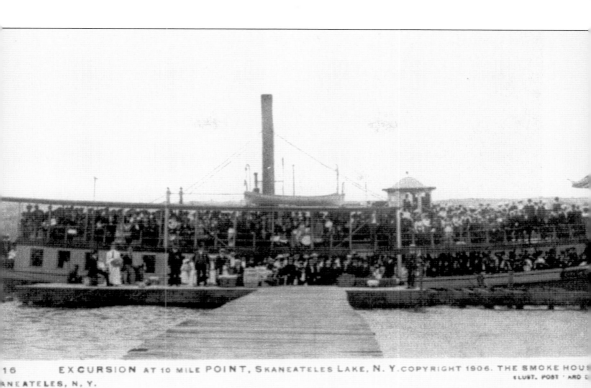

Docked at Ten Mile Point *c.* 1906, the steamer *Glen Haven* is absolutely packed full of people. It was built to carry 350 people and was 80 feet long. Built in 1876, it was used for 41 years. (Courtesy Skaneateles Historical Society.)

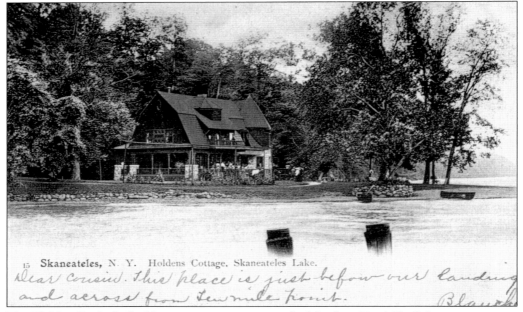

15 Skaneateles, N. Y. Holdens Cottage. Skaneateles Lake.

Dear Cousin. This place is just below our landing and across from ten mile point. Blauche

The Holden family built this summer cottage across the lake from Ten Mile Point.

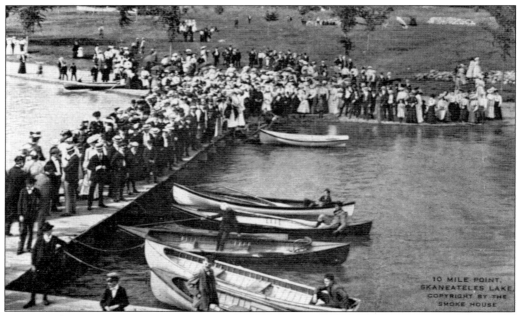

10 MILE POINT,
SKANEATELES LAKE
COPYRIGHT BY THE
SMOKE HOUSE

At Ten Mile Point, all of these people wait for a steamship to carry them back to Skaneateles.

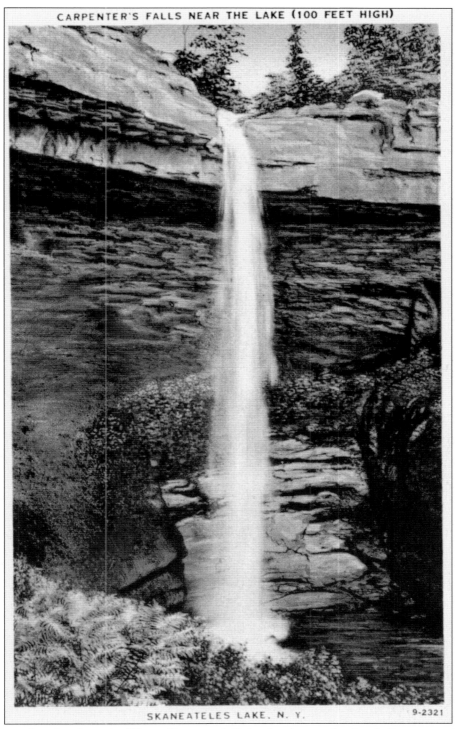

CARPENTER'S FALLS NEAR THE LAKE (100 FEET HIGH)

SKANEATELES LAKE, N. Y. 9-2321

For centuries, the dramatic falls at Carpenter's Point has been a landmark for area residents and tourists.

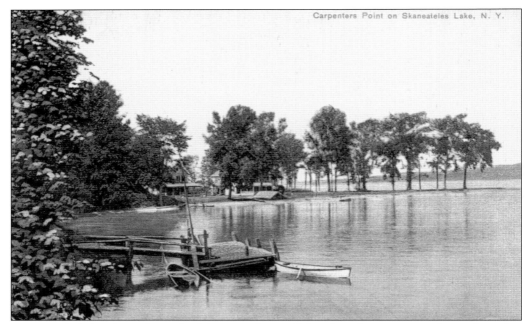

Carpenter's Point, located on the lake near the small hamlet of New Hope, featured modest summer cottages on its banks.

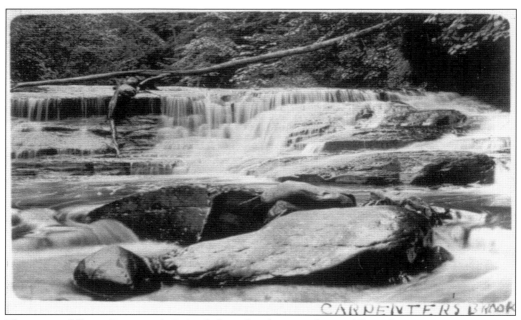

The upper falls at Carpenter's Point led to the dramatic lower falls, a favorite swimming hole carved out of the shale rock. (Courtesy Skaneateles Historical Society.)

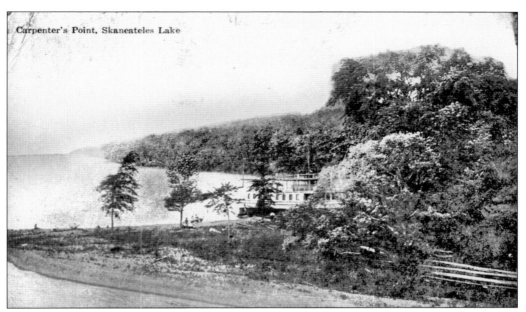

Carpenter's Point, Skaneateles Lake

The steamer *Ossahinta* was launched in June 1887 and, after years of service, was beached at Carpenter's Point in 1915.

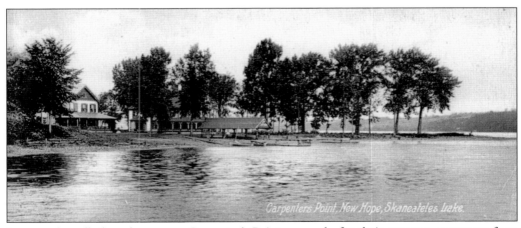

Carpenters Point, New Hope, Skaneateles Lake.

Large and small, these homes on Carpenter's Point are ready for their summer occupants from near and far.

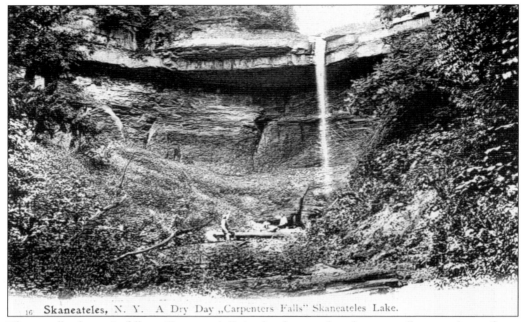

16 Skaneateles, N. Y. A Dry Day „Carpenters Falls" Skaneateles Lake.

The usually dramatic falls at Carpenter's Point has been reduced to a small stream here after a dry summer season.

The sun rises over Carpenter's Point in this scene from the 1940s.

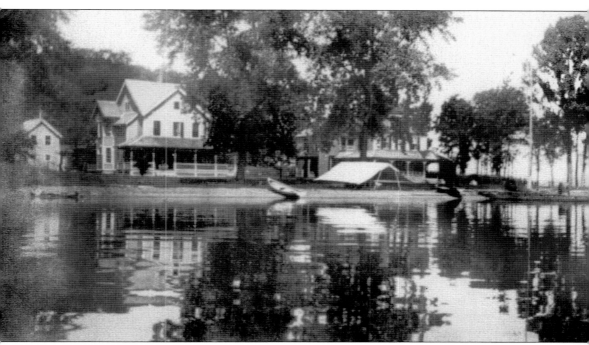

Large summer camps, such as these seen ringing the edge of the water at Carpenter's Point, have since been altered or razed. (Courtesy Skaneateles Historical Society.)

This elegant house had a lakeside tent erected on the beach at the time of this postcard, mailed in 1909.

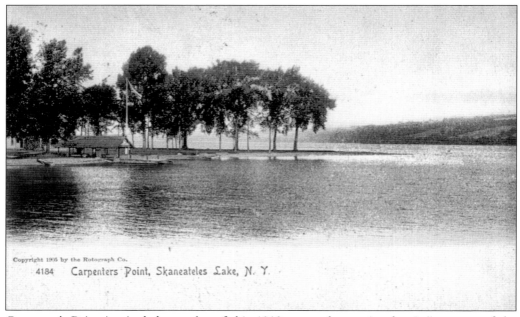

Copyright 1905 by the Rotograph Co.
4184 Carpenters Point, Skaneateles Lake, N. Y.

Carpenter's Point inspired the sender of this 1913 postcard to write that it "was one of the loveliest places" she had ever encountered.

74

This large unidentified house was known as one of the elegant summer homes on the shores of Skaneateles Lake c. 1907, the date this postcard was published. (Courtesy Skaneateles Historical Society.)

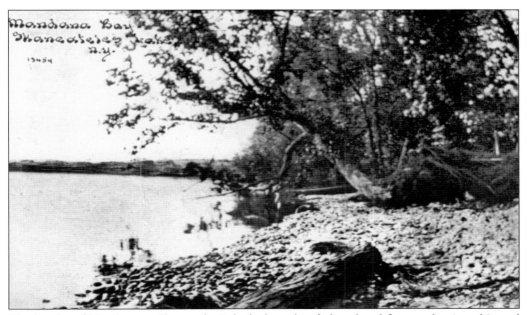

The hamlet of Mandana on Skaneateles Lake had a rather forlorn beachfront at the time this card was sent in 1918.

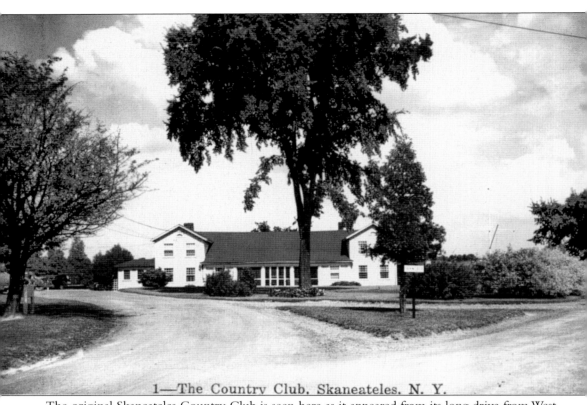

1—The Country Club, Skaneateles, N. Y.

The original Skaneateles Country Club is seen here as it appeared from its long drive from West Lake Road. It was built in 1917.

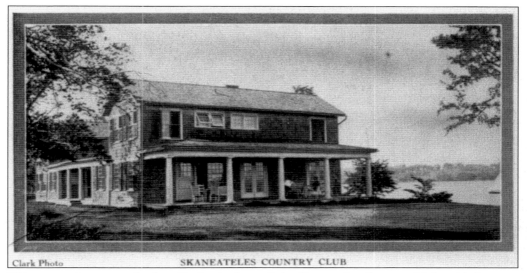

Clark Photo SKANEATELES COUNTRY CLUB

This postcard captures the humble beginnings of the Skaneateles Country Club, with its open porches and lakeside location. (Courtesy Skaneateles Historical Society.)

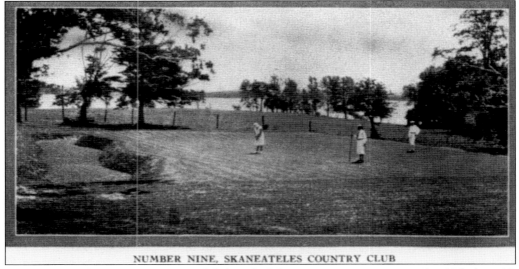

NUMBER NINE, SKANEATELES COUNTRY CLUB

Golfers at the Skaneateles Country Club have had the unique opportunity to play 18 holes with splendid views of the lake. (Courtesy Skaneateles Historical Society.)

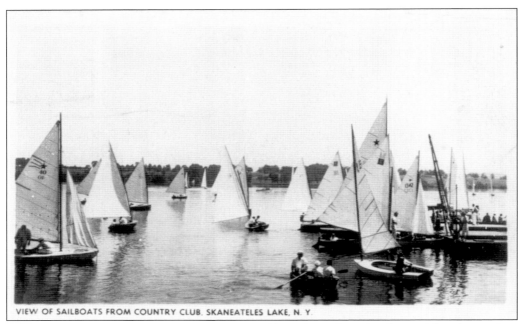

VIEW OF SAILBOATS FROM COUNTRY CLUB, SKANEATELES LAKE, N. Y.

With an obvious lack of wind on this fine day, sailboats leave from the shore of the Skaneateles Country Club.

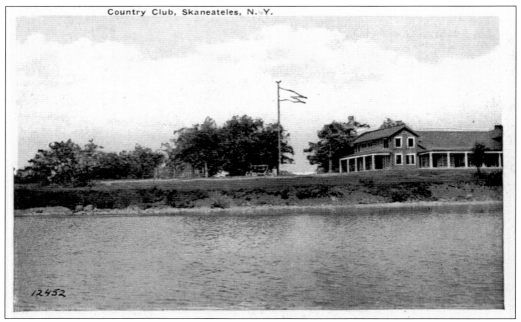

Country Club, Skaneateles, N. Y.

12452

A single Ford graces the parking lot of the Skaneateles Country Club. This postcard was published in the 1930s.

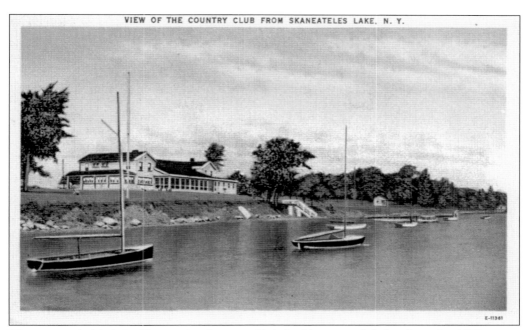

The sun sets behind the Skaneateles Country Club in this postcard dating from the 1950s.

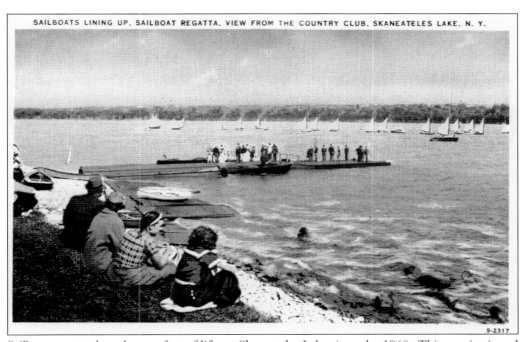

SAILBOATS LINING UP, SAILBOAT REGATTA, VIEW FROM THE COUNTRY CLUB, SKANEATELES LAKE, N. Y.

Sailboat regattas have been a fact of life on Skaneateles Lake since the 1860s. This one is viewed from the vantage point of the Skaneateles Country Club.

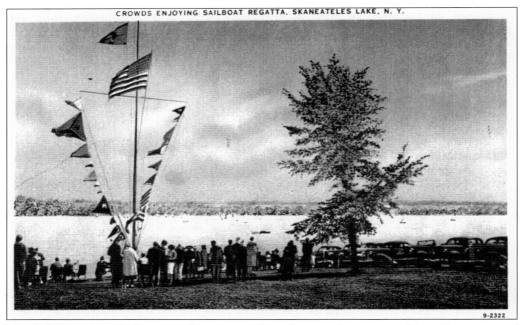

CROWDS ENJOYING SAILBOAT REGATTA, SKANEATELES LAKE, N. Y.

9-2322

Nautical flags add a festive atmosphere, as people gather to witness one of the sailboat races of the day.

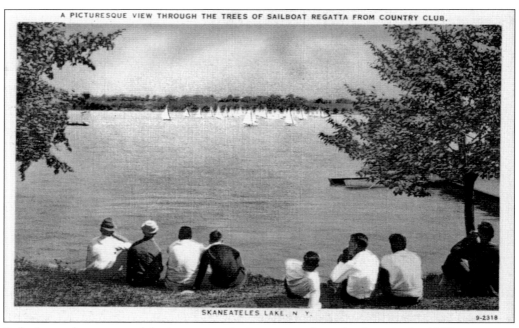

A PICTURESQUE VIEW THROUGH THE TREES OF SAILBOAT REGATTA FROM COUNTRY CLUB.

SKANEATELES LAKE, N. Y.

9-2318

Relaxing at the country club, these men take in a regatta from the shore in the 1950s.

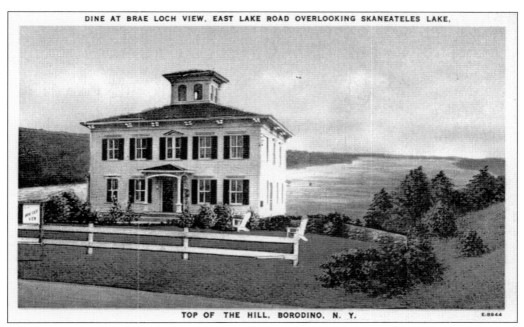

DINE AT BRAE LOCH VIEW, EAST LAKE ROAD OVERLOOKING SKANEATELES LAKE,

TOP OF THE HILL, BORODINO, N. Y. E-8944

This house on the hill overlooking Skaneateles Lake and the hamlet of Borodino was built in the 1880s. For the past several decades, it has served as various restaurants, including a recent incarnation as an elegant and welcome eatery called Cherrywood Inn.

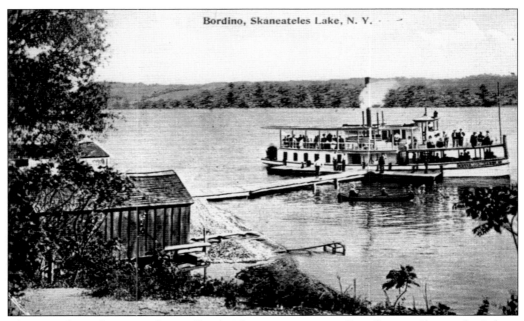

Bordino, Skaneateles Lake, N. Y.

The steamship *Glen Haven* drops off and picks up passengers at Borodino on Skaneateles Lake.

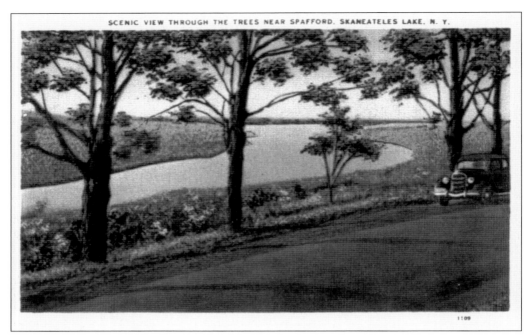

Skaneateles Lake is shown from Spafford Hill when the area was still primarily rural in nature. (Courtesy Skaneateles Historical Society.)

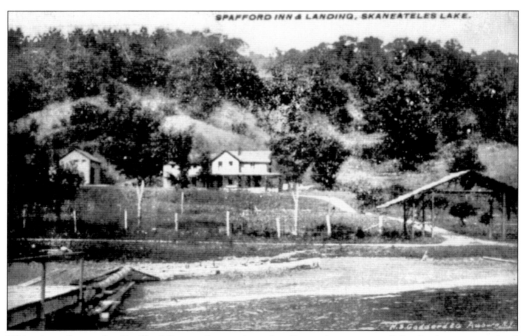

This view shows the Spafford Inn and steamboat landing, where most of the inn's guests arrived via the lake.

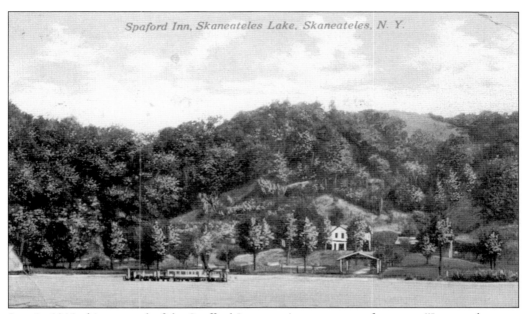

Sent in 1911, this postcard of the Spafford Inn contains a message of mystery: "In part cheer up, the worst is yet to come: wait until you hear what I have to tell you. Hank."

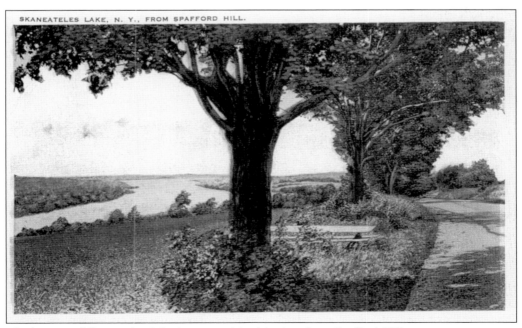

SKANEATELES LAKE, N. Y., FROM SPAFFORD HILL.

The beauty of Skaneateles Lake is captured in this view from Spafford Hill.

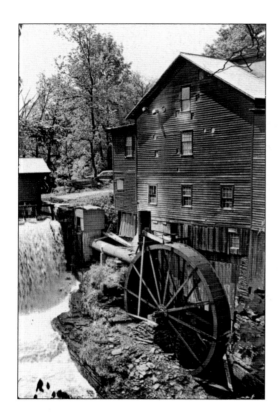

The well-known New Hope Mill has been producing flour and other goods since it first opened in 1823. Note the flour dust coming from the vents.

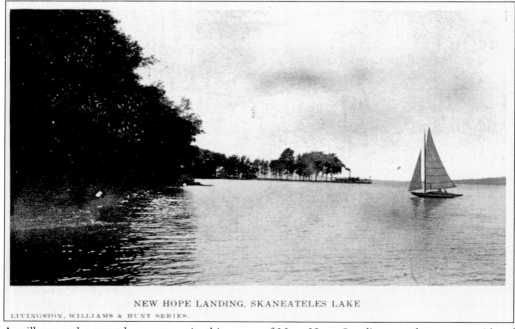

NEW HOPE LANDING, SKANEATELES LAKE
LIVINGSTON, WILLIAMS & HUNT SERIES.

A sailboat and a steamboat appear in this scene of New Hope Landing, on the western side of Skaneateles Lake.

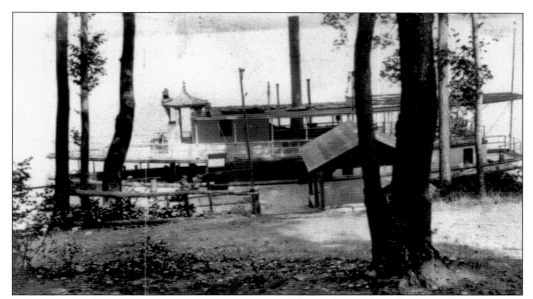

The steamer *Glen Haven is* docked at New Hope Landing, which featured a covered waiting area for protection during inclement weather. (Courtesy Skaneateles Historical Society.)

The stream that provided the power for the New Hope Mill has frozen solid. The ever-popular pancake mix produced at this mill is still available in local shops and markets. (Courtesy Skaneateles Historical Society.)

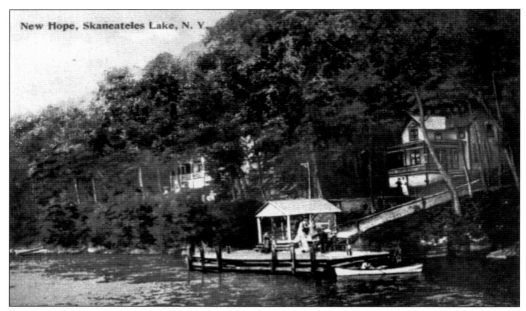

These cottages are part of the hamlet of New Hope on Skaneateles Lake. (Courtesy Skaneateles Historical Society.)

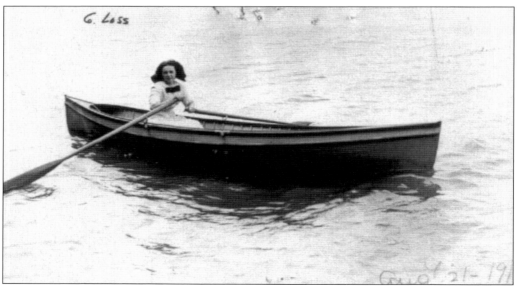

A young woman at the beginning of the 20th century enjoy a leisurely day of rowing at New Hope. (Courtesy Skaneateles Historical Society.)

At New Hope, Dean Howland (left) and Harold Loss sport their finest swimming wear during one fine day of a summer long ago. (Courtesy Skaneateles Historical Society.)

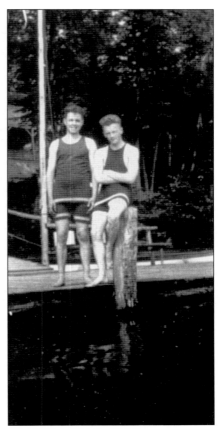

Harold Loss (left) is seen here on the porch of his rental summer cottage at New Hope. (Courtesy Skaneateles Historical Society.)

The steamboat landing at New Hope featured this rather unusual floating dock and waiting area. (Courtesy Skaneateles Historical Society.)

A few of the many lakefront summer cottages at New Hope are seen here in this undated postcard. (Courtesy Skaneateles Historical Society.)

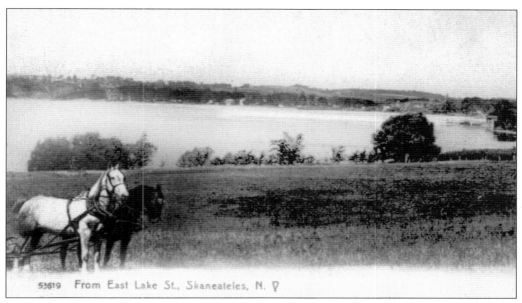

A team of farm horses pauses on East Lake Street, not far from the village of Skaneateles. (Courtesy Skaneateles Historical Society.)

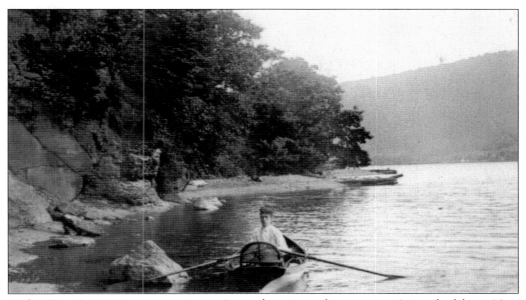

In this Victorian scene, a young woman in an elegant wooden canoe navigates the lake at New Hope. (Courtesy Skaneateles Historical Society.)

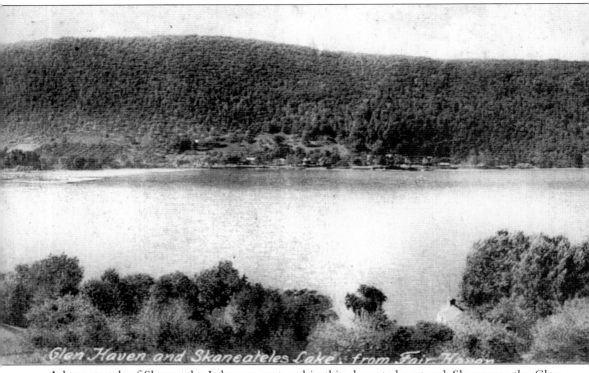

Glen Haven and Skaneateles Lake from Fair Haven

A long stretch of Skaneateles Lake was captured in this elongated postcard. Shown are the Glen Haven resort (on the west side) and the bend in the lake, leading eventually to the village of

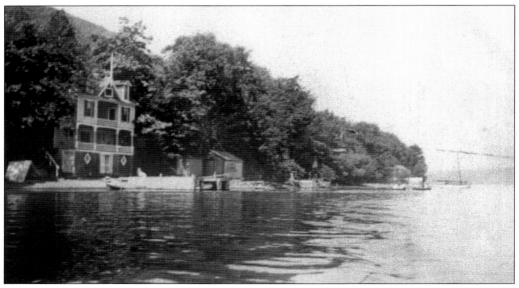

These elegant cottages once graced the shores of Skaneateles Lake. (Courtesy Skaneateles Historical Society.)

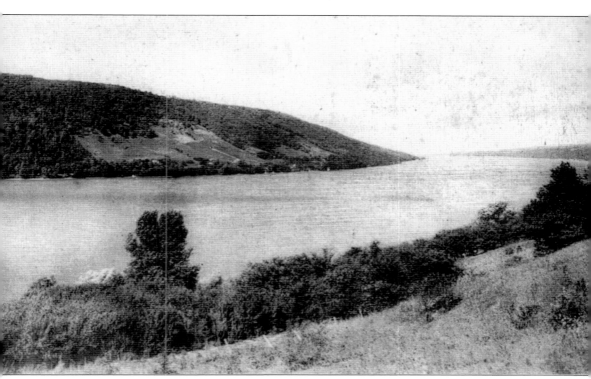

Skaneateles (to the right).

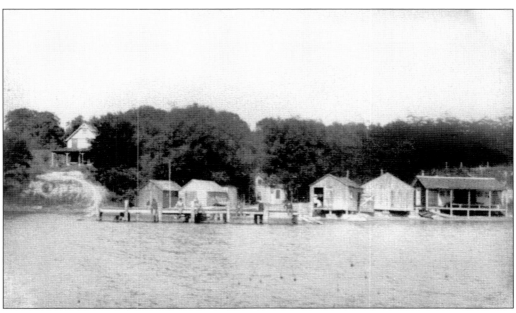

Rows of boathouses, likely converted from icehouses, are seen here near a summer cottage at an unidentified location on Skaneateles Lake. (Courtesy Skaneateles Historical Society.)

46437

The far south end of Skaneateles Lake is characterized by steep rolling hills, often requiring lakeside residents to come and go exclusively by boat.

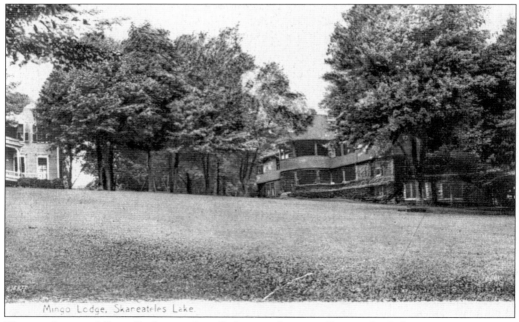

Mingo Lodge, Skaneateles Lake.

The vast lawn at Mingo Lodge reaches all the way down to Skaneateles Lake.

This unidentified house in or near the village of Skaneateles features a luxurious lawn and a boathouse directly on the lake.

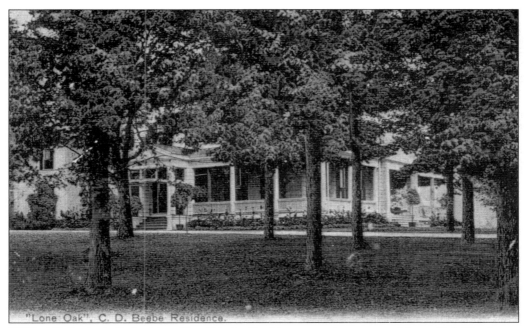

"Lone Oak", C. D. Beebe Residence.

Clifford D. Beebe built for himself and his family this summer home named Lone Oak. The house is located just north of the current country club.

This shore at the southern edge of the lake demonstrates the harsh conditions many encountered in attempting to build a summer home along its edge.

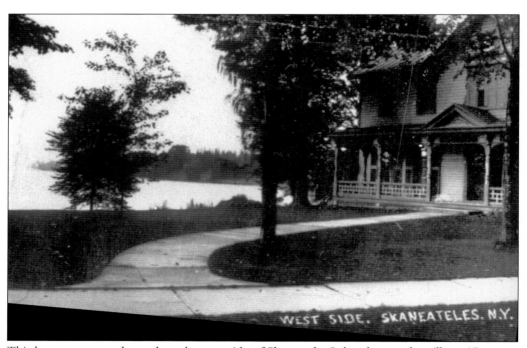

This house was once located on the west side of Skaneateles Lake, close to the village. (Courtesy Skaneateles Historical Society.)

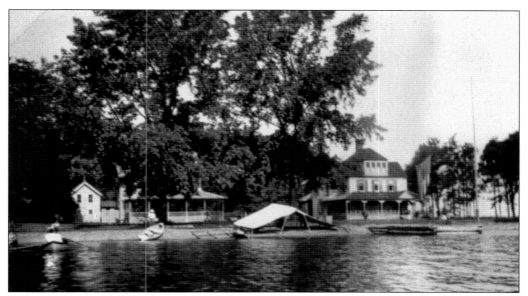

These cottages at New Hope were typical of the clusters of summer homes that once surrounded the lake. (Courtesy Skaneateles Historical Society.)

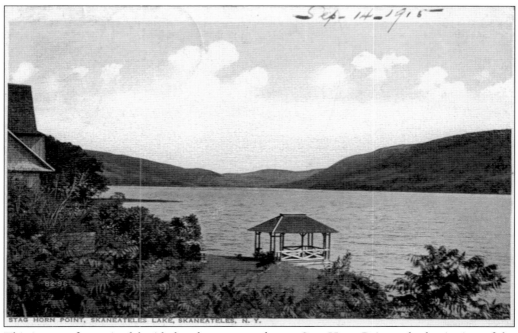

This image of a quaint lakeside boathouse was taken at Stag Horn Point *c.* the beginning of the 20th century.

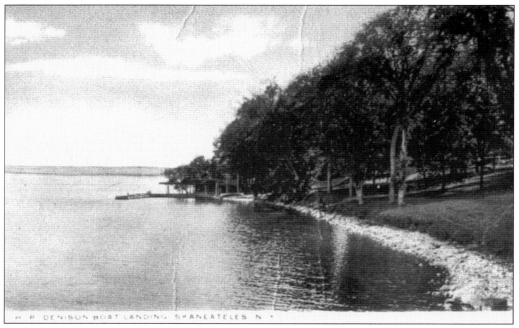

H.P. Denison was one of the many summer camp owners who constructed a private pier for the myriad steamships that once traversed the lake. (Courtesy Skaneateles Historical Society.)

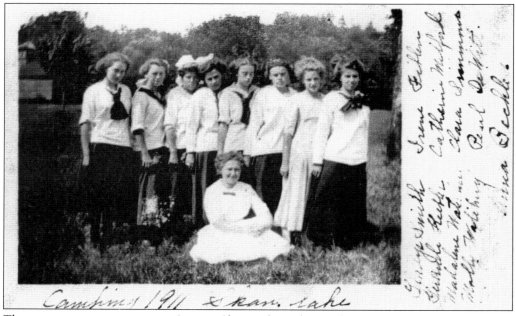

These young women are camping on Skaneateles Lake in the summer of 1911. (Courtesy Skaneateles Historical Society.)

Four

SAILING AND BOATING

Skaneateles Lake has always been synonymous with boating and sailing, with the village itself serving as the site of many boat manufacturers. These locally built boats have, of course, been tested and purchased for use on Skaneateles Lake, and many of them remain on the lake today. The first era of boating on the lake, however, featured the large and small steamships that were designed to carry both hotel guests and private residents to and from the Skaneateles pier to points south along the lake. Many passengers would arrive in the village from the train service that ran into the city of Syracuse.

Although the first steamboat recorded to traverse the waters of Skaneateles was launched in 1831, the steamer *Ben H. Porter* was one of the first large steamers to appear. Launched on August 6, 1866, it completed its service in 1875. After a reconfiguration as a schooner, it was converted for use as a dock near Spafford. It joined several others, including the *Homer, City of Syracuse, Ossahinta,* and *Glen Haven.* The largest of these was the *City of Syracuse,* which held an incredible 600 passengers.

The first boat company to do business in Skaneateles was established in the 1880s under the name Bowdish & Company. The company manufactured rowboats, canoes, small steamboats, and large sloops. Its factory on Fennell Street burned in 1899 and was not rebuilt.

The Skaneateles Boat and Canoe Company was established by George Smith and James Ruth in 1893. In 1932, after a disastrous fire at the company's Jordan Road location, it was taken over by George and John Barnes, who produced the world-famous Lightning sailboat in 1937 and the Rhodes Bantam in 1946. The Lightning was designed as a family sailing vessel that could also be used in racing events. It proved one of the company's most popular boats. During World War II, the company worked on several experimental watercraft for the U.S. Navy.

One of the first sailboats on Skaneateles Lake was the ketch dinghy, a somewhat oversized wooden boat with three small sails. The Skaneateles Fire Department launched the *Phantom* in Clift Park in 1911. Mail was even delivered via boat, beginning in 1922 on the *Florence.* It was delivered to those lakefront homes on the southern portions of the lake with property too steep for normal car delivery. Baskets on docks and rafts are still used today on a subsequent mailboat owned and operated by the Mid Lakes Navigation Company, a true fixture in the village. Today, the company operates two tourist boats on the lake: the *Barbara S. Wiles* and the *Judge Ben Wiles.*

Whatever the date and origin of the boat, Skaneateles residents and visitors alike are used to witnessing myriad old and new boats on the lake for current-day recreation or an annual gathering of antique-boat enthusiasts.

The Skaneateles Boat Company, founded by George Smith and James Ruth, produced and delivered a variety of highly desired sailboats throughout the country. (Courtesy Skaneateles Historical Society.)

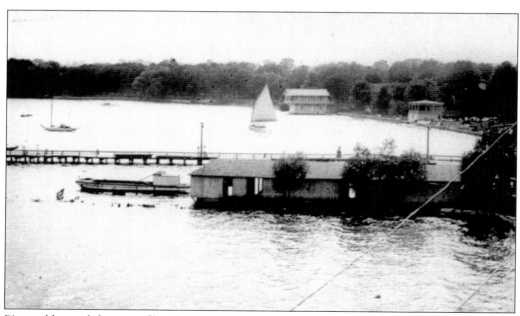

Pictured beyond the row of boathouses are the long wood pier, some sailboats, and the bandstand in Clift Park.

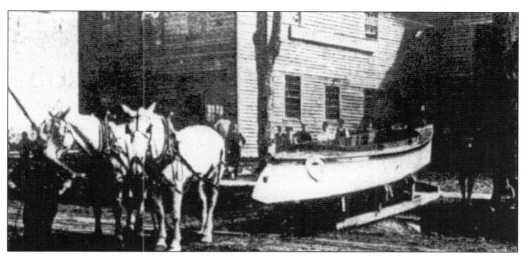

The *Quaker Lady* heads to its launching on July 4, 1906, pulled by horses on a rail. It was built for owner William H. Olmsted. (Courtesy Skaneateles Historical Society.)

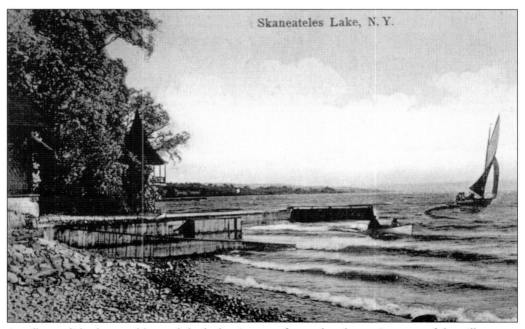

Skaneateles Lake, N.Y.

A sailboat glides by an old wood dock that juts out from a boathouse just east of the village.

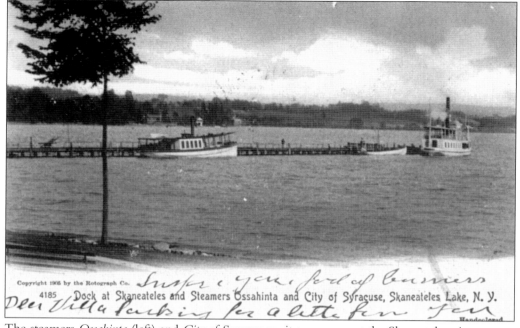

Insure you, feel of business

4185 Dock at Skaneateles and Steamers Ossahinta and City of Syracuse, Skaneateles Lake, N. Y.

Dew Villa parking for a little fun Jen

The steamers *Ossahinta* (left) and *City of Syracuse* await passengers at the Skaneateles pier.

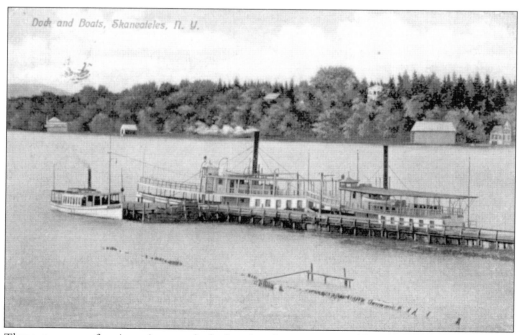

Dock and Boats, Skaneateles, N. U.

Three steamers of various sizes are docked at the pier next to an older submerged pier.

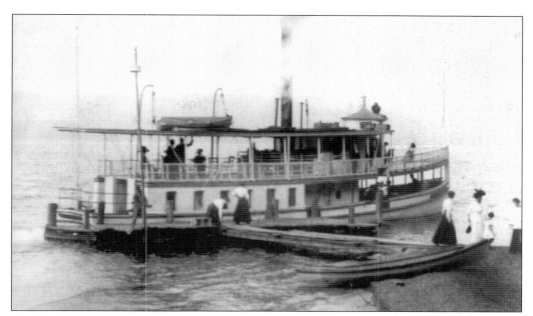

Passengers board the *Glen Haven* via a rather precarious dock at this unidentified location on the lake. (Courtesy Skaneateles Historical Society.)

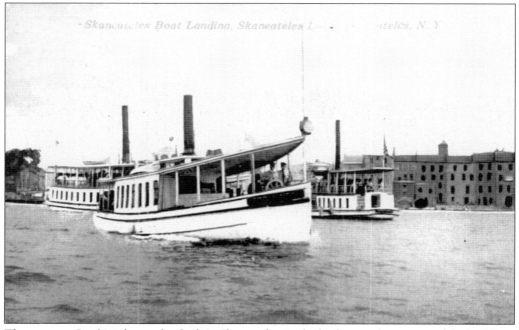

Skaneateles Boat Landing, Skaneateles L . nteles, N. Y

The steamer *Ossahinta* leaves the dock in Skaneateles. In the background are some of the buildings on Genesee Street.

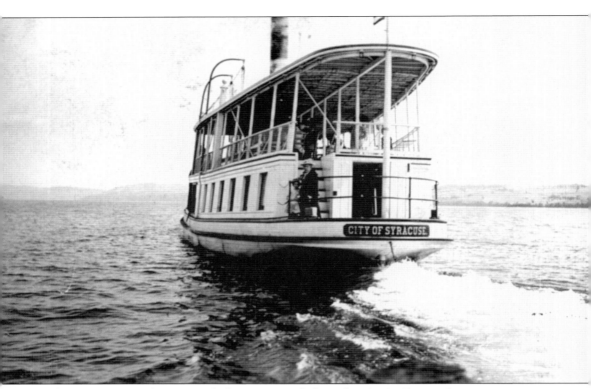

The steamer *City of Syracuse* sails for points south from the pier in Skaneateles.

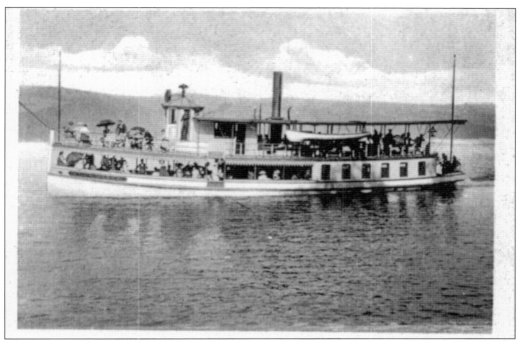

The steamer *Glen Haven*, one of the many steamships that graced Skaneateles Lake during days long gone, traverses the lake.

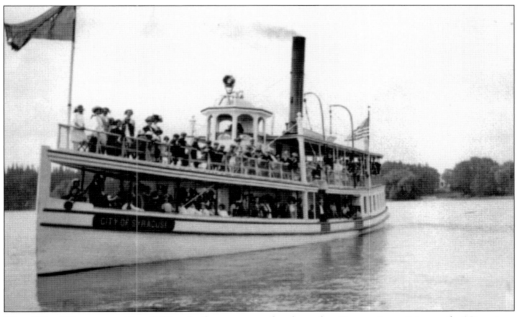

The *City of Syracuse*, with a full load of passengers, slowly makes its way to points south. (Courtesy Skaneateles Historical Society.)

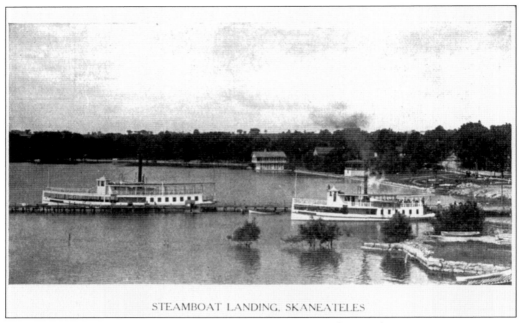

STEAMBOAT LANDING, SKANEATELES

The *Ossahinta* leaves the Skaneateles pier as another steamer takes its place.

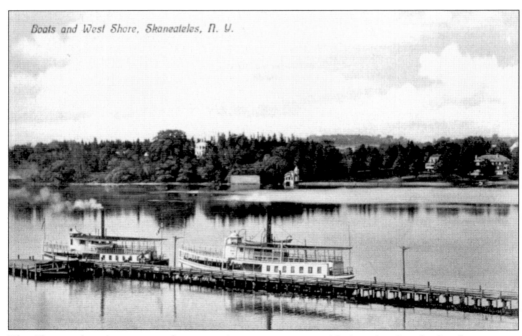

Boats and West Shore, Skaneateles, N. Y.

The Skaneateles pier was a rather precarious structure, considering that hundreds of passengers could be on it at one time, embarking and disembarking one of the many steamboats that came and went during the day.

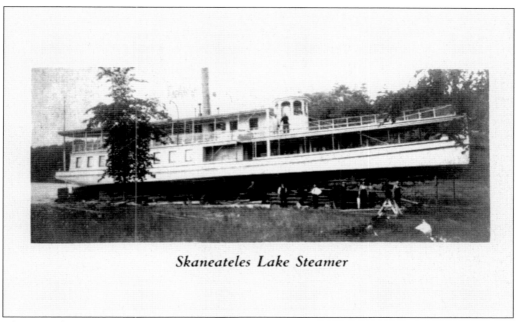

Skaneateles Lake Steamer

The *City of Syracuse* is shown being launched on July 6, 1901. With a passenger load of 600 people, it was piloted by Capt. Fay Clark and owned by Samuel Allen.

Many of the homes along the southern portion of the lake were accessible only by boat. Thus, Charles Keegan, who had a contract with the government to deliver mail, built the *Florence* in 1922 as a mailboat. The Mid Lakes Navigation Company built a re-creation of the *Florence*. Still in use today, it is one of the few mailboats left in the United States.

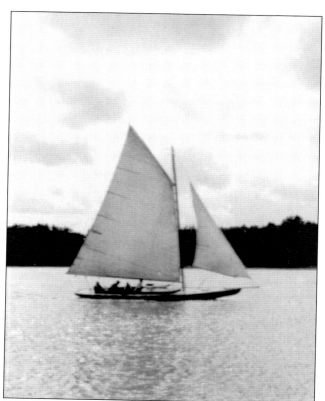

A sailboat belonging to Harry Pierce is seen here on the lake in the early 1900s. (Courtesy Skaneateles Historical Society.)

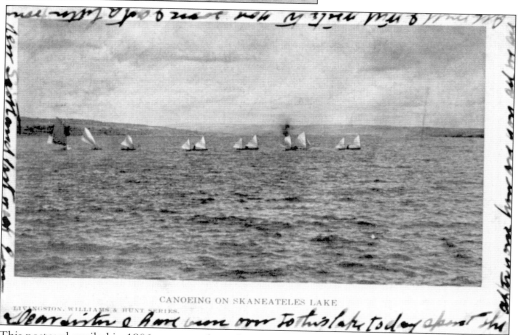

CANOEING ON SKANEATELES LAKE

LIVINGSTON, WILLIAMS & HUNT SERIES.

This postcard, mailed in 1906, captures the rather unusual practice of sailing canoes on Skaneateles Lake.

The blue waters of Skaneateles Lake have been the scene of many elegant wooden sailboats over the past two centuries, such as these two fine specimens. (Courtesy Skaneateles Historical Society.)

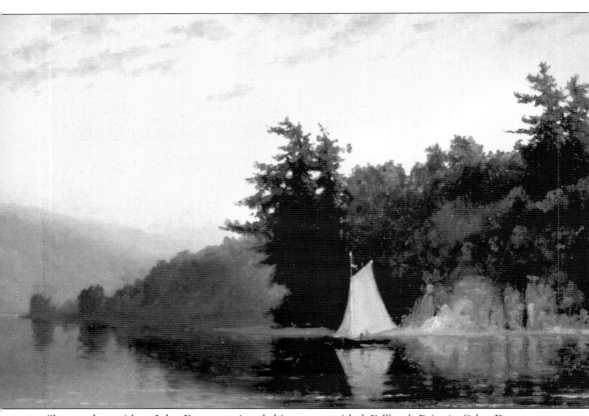

Skaneateles resident John Barrow painted this scene entitled *Fallbrook Point in Other Days.*

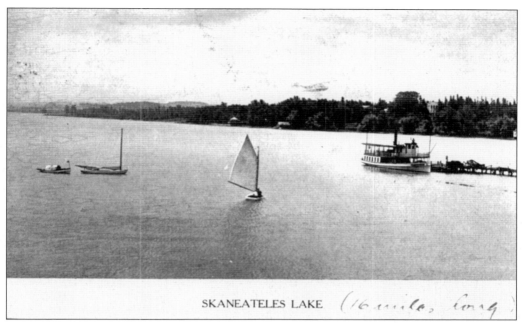

SKANEATELES LAKE *(16 miles, long)*

This scene of the placid waters of the lake was printed on a card postmarked 1905.

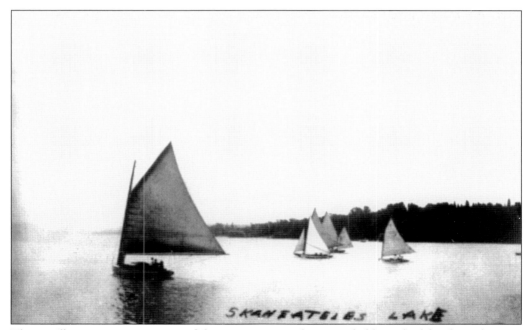

SKANEATELES LAKE

These sailboats compete in one of the many races and regattas held on the lake throughout its history. (Courtesy Skaneateles Historical Society.)

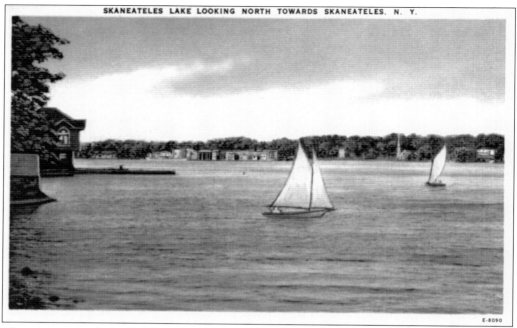

E-8090

These boats are pictured offshore on the west side of Skaneateles Lake in the 1940s.

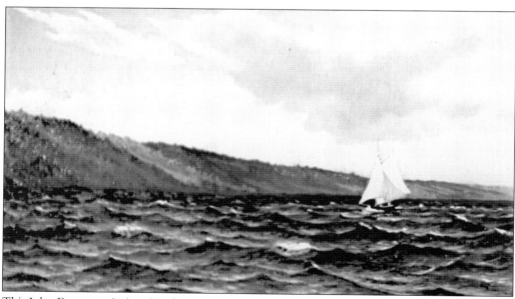

This John Barrow painting, *Northwest Wind on Skaneateles Lake,* captures the spirit of many a sailor who has sailed on these royal blue waters.

Five

RESORTS AND HOTELS

Skaneateles summer residents and travelers from afar boarded steamships at the village pier, bound for many points and places on the lakeshores, most notably the Glen Haven Hotel and Water Cure, but other destinations of smaller hotel and resort areas as well, and even private residences and camping grounds.

The best-known hotel on Skaneateles Lake, and perhaps that of surrounding lakes as well, was the Glen Haven Hotel and Water Cure, established by a group of physicians in 1846. There, they attempted a variety of water cures for various health ailments, attracting guests from all over the world to take advantage of the "purist water in the world." The hotel featured its own dairy, vegetable gardens, farm, and electricity plant, thanks to boilers and engines removed from the steamer *Ben H. Porter.*

The Glen Haven Water Cure evolved from a private house owned by Deacon David Hall and purchased by Dr. Silas Gleason and his wife, Rachel, in 1846 to be used as a retreat for hydropathy treatments. It was configured with a piped water system, with soft water coming from a spring flowing from the cliffs above.

Residents of the early water cure enjoyed diversions such as dancing, musical presentations, boating, and swimming, but followed closely a regimen of diet, exercise, rest, and relaxation. The facility was later expanded and, in 1885, the Glen Haven Hotel was born.

Patients underwent such hydropathy treatments as having to wear skullcaps kept constantly moist, and they were awakened at 4:00 each morning to undergo a wrap of moist towels for the entire body, all the time drinking several glasses of water per hour. The business boomed, and many cottages were built on the property to accommodate the ever-increasing number of guests. The ultimate demise of the hotel complex came in 1911, when the city of Syracuse condemned the property for fear that its treatments might harm the drinking water source for the city.

Other resort areas of the lake thrived, however, attracting guests at smaller hotels and more modest camping grounds, all accessible from the steamships and, later, by automobile. Groups of summer camps were built as rental investments beginning *c.* 1900, when smaller hotels also began to play off the well-publicized purity of the lake's water and the area's relaxing qualities.

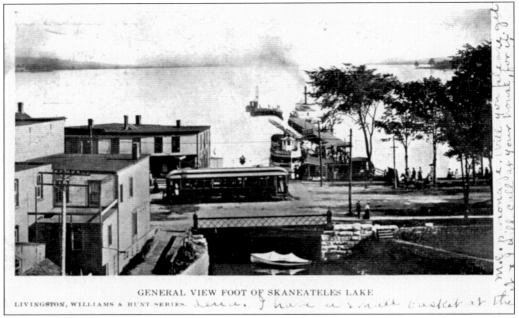

GENERAL VIEW FOOT OF SKANEATELES LAKE
LIVINGSTON, WILLIAMS & HUNT SERIES.

This busy scene took place in the village of Skaneateles and shows the varied transportation available to area residents and visitors.

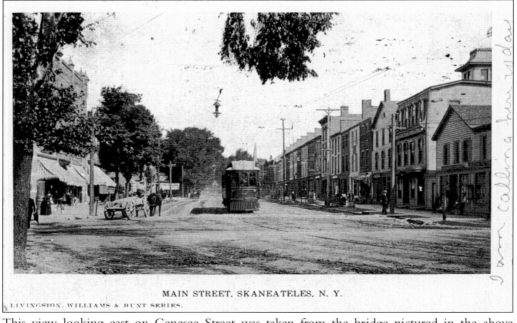

MAIN STREET, SKANEATELES, N. Y.
LIVINGSTON, WILLIAMS & HUNT SERIES.

This view looking east on Genesee Street was taken from the bridge pictured in the above postcard. This card was postmarked 1907.

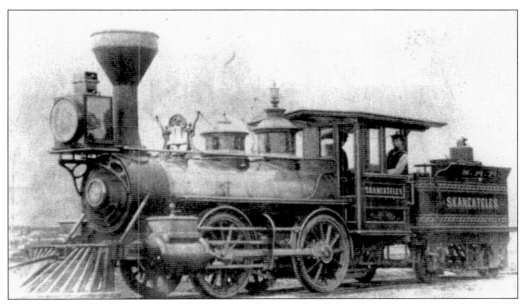

In what is believed to be the oldest known photograph of the Skaneateles Railroad (*c.* 1868), Martin Fennell is shown as the engineer of Locomotive No. 1. Passengers on the train from Syracuse could connect with a steamboat in the village to the resorts and water cures located on the lakeshore.

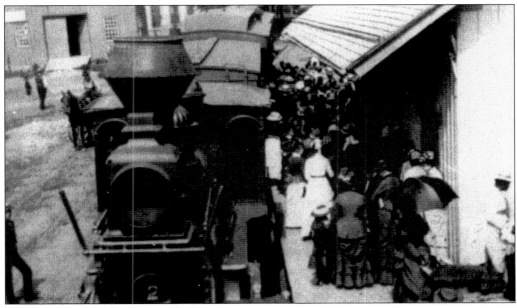

A locomotive similar to the No. 1 shown above stops at the Fennell Street Station. Women in long dresses carry parasols to shade them from the sun.

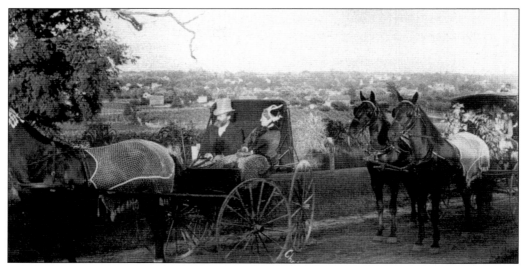

The resort at Glen Haven was not always approached by boat, as this image by William Seward Jr. shows. William Seward took the photograph during a ride to the resort from his Owasco Lake summer camp called Willowbrook. (Courtesy Seward House Archives.)

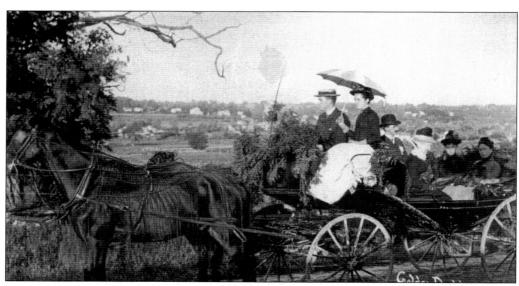

Another carriage in the Seward party en route to the Glen Haven Hotel overland from Owasco Lake was decorated with goldenrod. This was part of a festive decorating contest in which each carriage owner was encouraged to participate. (Courtesy Seward House Archives.)

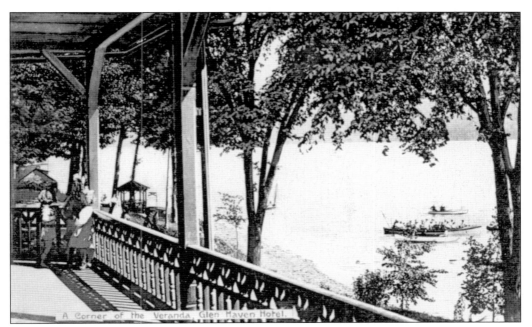

A Corner of the Veranda, Glen Haven Hotel.

Skaneateles Lake can be seen from the front porch of the Glen Haven Hotel and Water Cure, with a small steamer of passengers approaching the landing. The hotel was founded in 1846 and was operated by physicians who specialized in the treatment of various ailments with the pure water found on its shore.

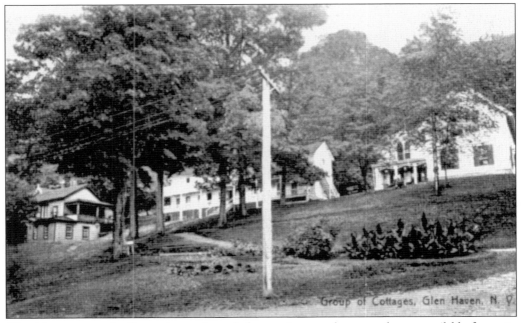

Group of Cottages, Glen Haven, N. Y.

Glen Haven resort also featured several stand-alone cottages and summer homes available for rent.

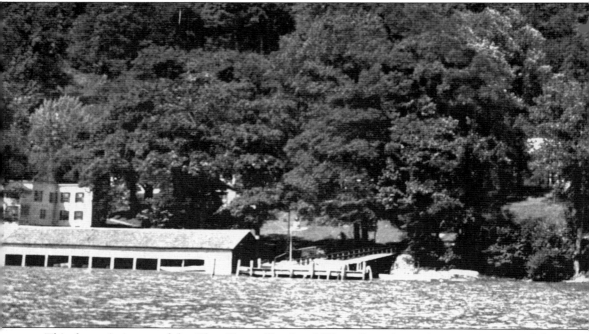

This dramatic image of the Glen Haven Hotel and Water Cure shows the extensive area of the complex and its multiple boathouses. The resort was open from June to November and charged

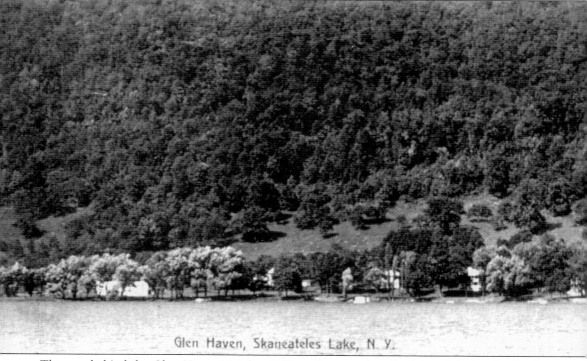

Glen Haven, Skaneateles Lake, N. Y.

The area behind the Glen Haven Hotel and Water Cure was heavily forested during the heyday of the hotel. Many of its guests came from distant places to take part in its often strange water

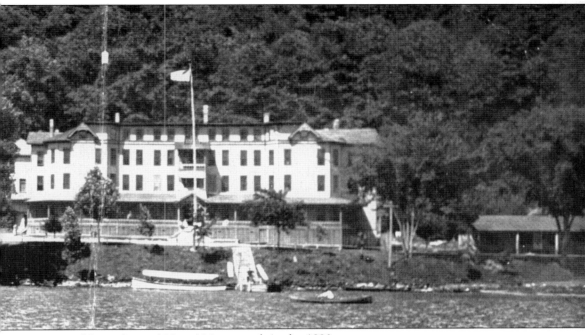

its guests $2 per day or $10 to $14 per week in the 1890s.

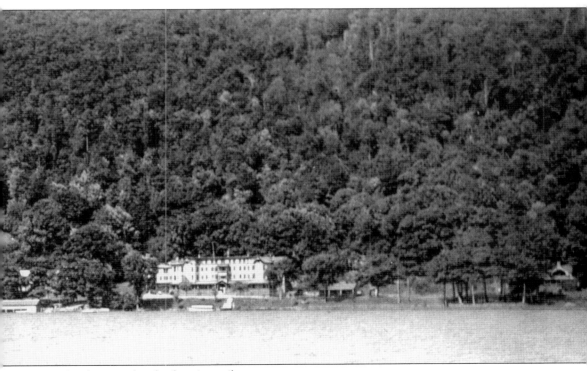

cures, implemented to heal various ailments.

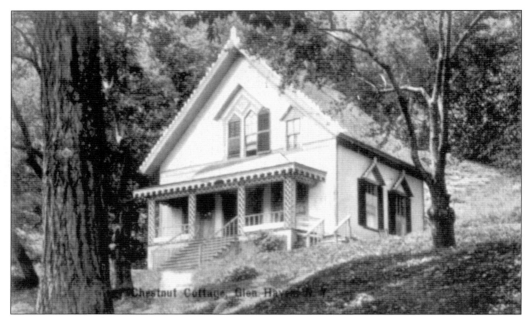

This camp at the Glen Haven resort was named Chestnut Cottage. (Courtesy Skaneateles Historical Society.)

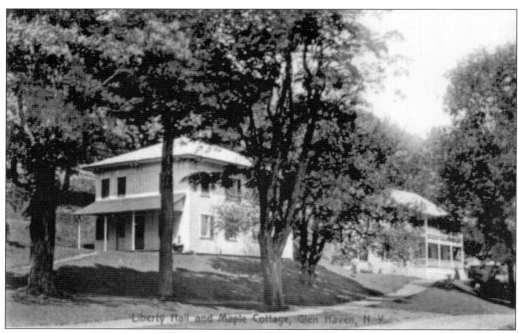

Liberty Hall and Maple Cottage were included in this postcard of the Glen Haven complex. The hotel advertised that it was "free from malaria and mosquitoes." (Courtesy Skaneateles Historical Society.)

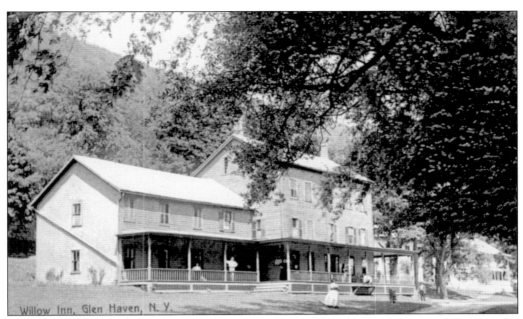

The Willow Inn at Glen Haven was another summer hotel built for the enjoyment of guests who came to escape the heat and busyness of large cities.

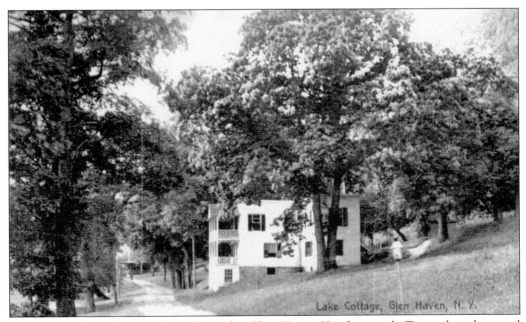

Seen here is Lake Cottage, located on the Glen Haven Hotel grounds. To produce heat and power, the hotel used the boiler and engines that were removed from the steamer *Ben H. Porter* in 1875.

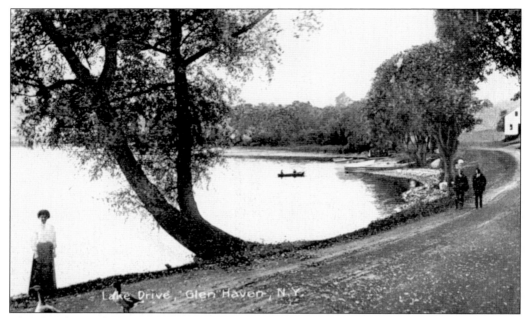

The shorefront of Glen Haven was an ideal place for swimming and, in this case, feeding ducks.

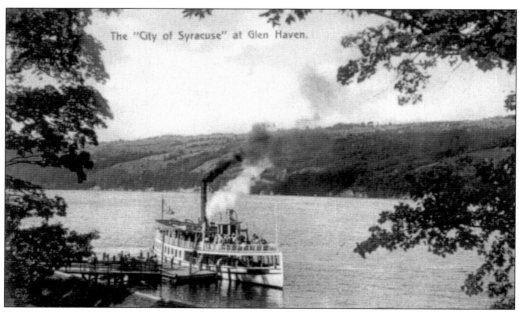

The steamer *City of Syracuse* drops off passengers at the Glen Haven Hotel. (Courtesy Skaneateles Historical Society.)

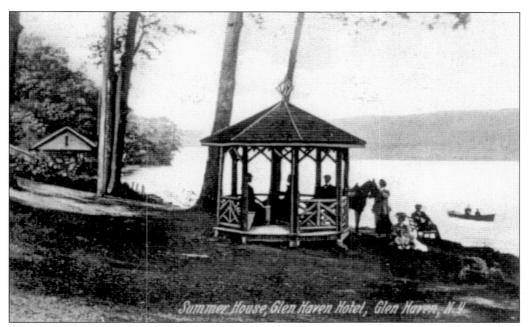

This elegant lakeside gazebo at Glen Haven was undoubtedly a summer meeting place for romance and picnicking. (Courtesy Skaneateles Historical Society.)

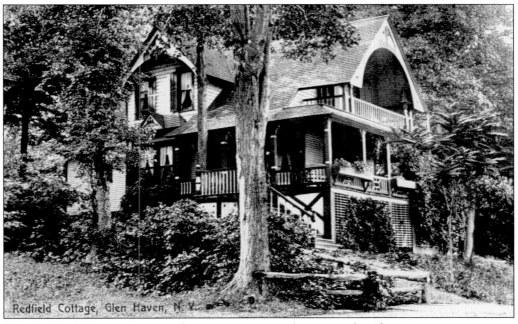

The Redfield Cottage was one of many summer rental camps at the Glen Haven resort.

The peaceful setting of Glen Haven's grounds and summer cottages was captured in this postcard, sent from the resort in 1910. The hotel was closed and torn down in 1911.

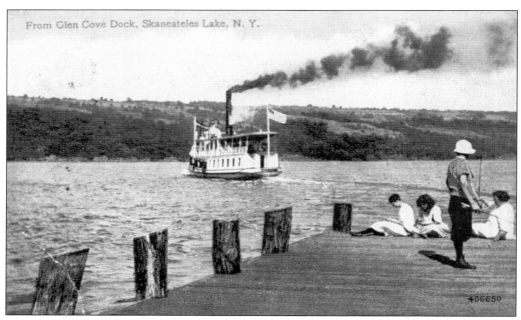

Guests left behind watch as the steamer leaves the Glen Cove dock on a hot summer day long ago.

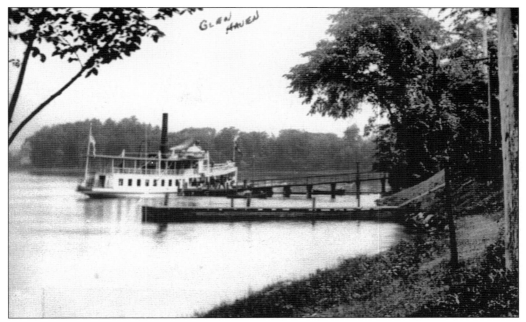

The *City of Syracuse* is seen here at the dock of the Glen Haven Hotel, with several passengers eagerly disembarking, ready to explore the resort's vast grounds.

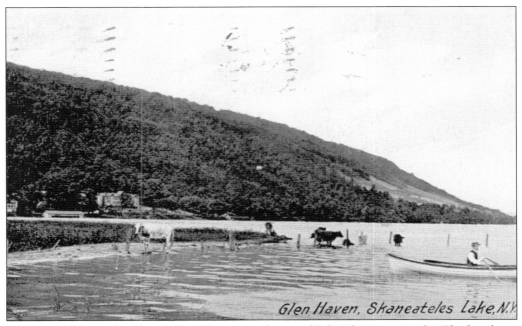

Glen Haven, Skaneateles Lake, N.Y.

Cows are enjoying the lake at Glen Haven on what was likely a hot summer day. The hotel was mostly self-sufficient with regards to its own dairy and farmland.

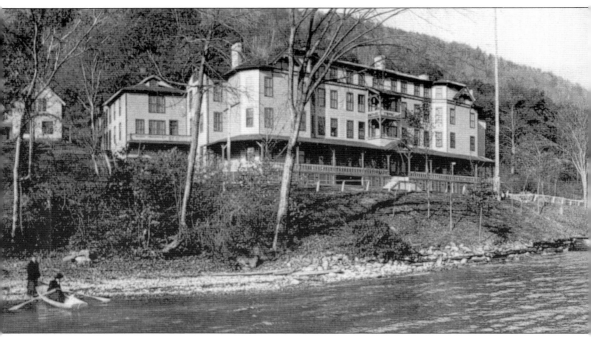

This closeup of the Glen Haven Hotel shows the elegantly styled building, designed to catch even

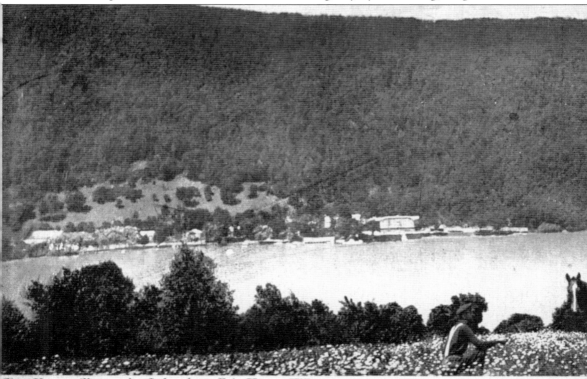

Glen Haven, Skaneateles Lake, from Fair Haven Hills.

Horses add to this view of the southern portion of Skaneateles Lake from a farm overlooking the

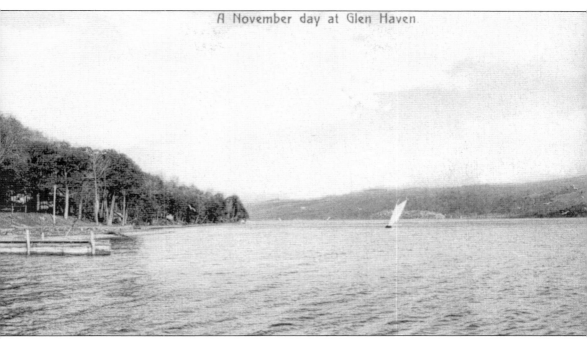

the calmest breeze off the water.

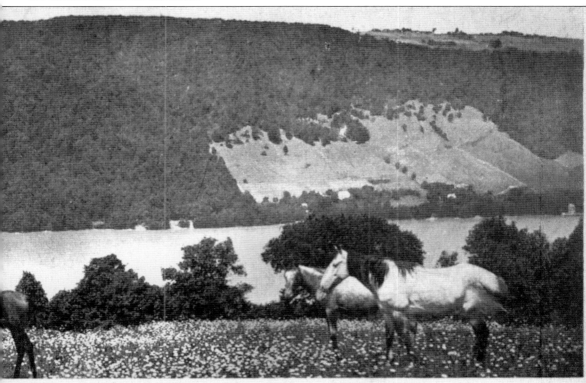

gorge, with Glen Haven in the background.

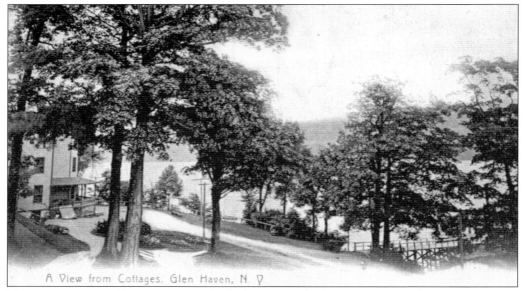

A View from Cottages, Glen Haven, N. Y.

These cottages at Glen Haven overlooked a rustic bridge connecting them to the main hotel building.

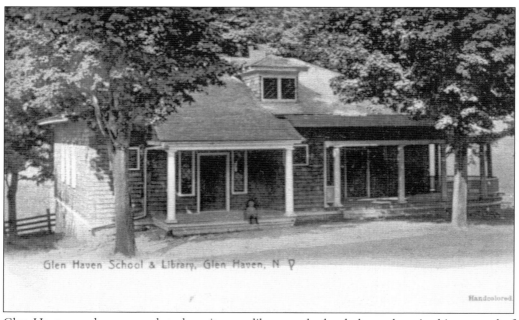

Glen Haven School & Library, Glen Haven, N. Y.

Handcolored

Glen Haven was large enough to have its own library and school, shown here in this postcard of the era. (Courtesy Skaneateles Historical Society.)

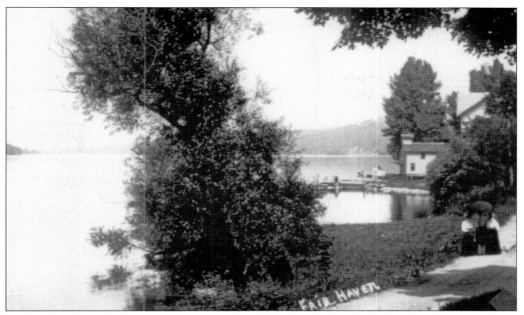

Another group of cottages used for summer rental was located at Fair Haven on Skaneateles Lake. Note the small wooden chapel at the water's edge.

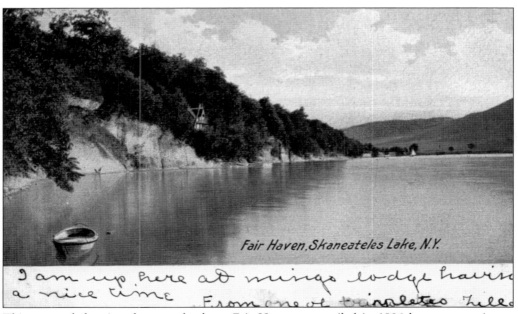

This postcard showing the steep banks at Fair Haven was mailed in 1906 by guests staying at Mingo Lodge (see page 92).

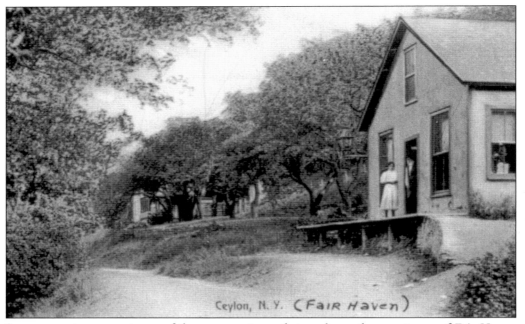

Ceylon, N.Y. (FAIR HAVEN)

Summer renters pose at one of the many cottages that made up the resort area of Fair Haven. (Courtesy Skaneateles Historical Society.)

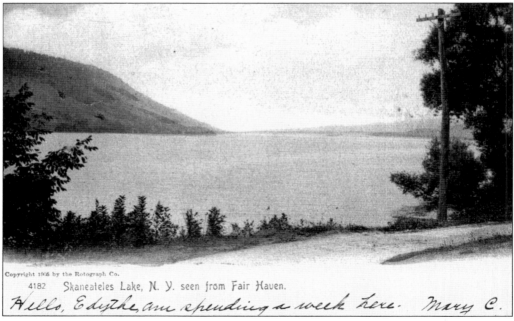

Copyright 1905 by the Rotograph Co.

4182 Skaneateles Lake, N. Y. seen from Fair Haven.

Hello, Edythe, am spending a week here. Mary C.

This lovely scene at Fair Haven on Skaneateles Lake has undoubtedly been enjoyed by all those who have had the opportunity to be on the lake's waters in the past.